MARTHA'S VINEYARD

MARTHA'S VINEYARD

A History

THOMAS DRESSER

THE
History
PRESS

Published by The History Press
Charleston, SC 29403
www.historypress.net

Front cover, top: Ox carts provided transportation to tourists at Gay Head in the nineteenth century. *Photo from the collection of Connie Sanborn. Bottom*: Edgartown Lighthouse. *Photo by Moe Homayounieh.*

Back cover, top: Section of the Eldridge Map, 1913. *Courtesy of the Norman B. Leventhal Map Center at the Boston Public Library. Middle*: Charles W. Morgan, the oldest commercial ship still afloat. *Photo by Joyce Dresser. Bottom*: Vineyard Haven Harbor from the ferry. *Photo by Moe Homayounieh.*

First published 2015

Manufactured in the United States

ISBN 978.1.62619.376.5

Library of Congress Control Number: 2015931741

Notice: The information in this book is true and complete to the best of our knowledge. It is offered without guarantee on the part of the author or The History Press. The author and The History Press disclaim all liability in connection with the use of this book.

Pat Gregory came to Martha's Vineyard from off-island in 1972 and made his mark on the Vineyard as teacher, coach and businessman, as well as town moderator for two decades in West Tisbury. His senseless murder while hiking in California, at age sixty-nine, in the spring of 2014, shocked the Vineyard. He was one of us, and now he is gone. This book is dedicated to him.

CONTENTS

Foreword, by John Hough Jr. 9
Preface 11
Acknowledgements 13

1. Noepe, Land Amid the Waters 17
2. Who Was Martha? 23
3. The Missionary Mayhews 27
4. Revolutionary Economics and War 32
5. Thar She Blows 39
6. Wha's That? 46
7. Of Fairs and Revivals 54
8. The Industrial Revolution 64
9. Land Management, Part 1 74
10. Early Twentieth Century 86
11. The Grim Reaper 97
12. World War II on Martha's Vineyard 104
13. The Frugal '50s 107
14. The Singing '60s 118
15. The Swinging '70s 121
16. Land Management, Part 2 131
17. Hail to the Chiefs 137
18. The Twenty-first Century 143

CONTENTS

Epilogue 149
A Tour of Martha's Vineyard 151
Notes 161
Bibliography 167
Index 169
About the Author 171

FOREWORD

On a summer day in 1861, three Vineyard boys—Peleg Davenport, Bart Crowell and Elisha Smith—made their way to Edgartown, where a recruiter had ensconced himself for the day, and enlisted in the Union army. Elisha was the youngest of the three; he was sixteen. The boys were soon in the thick of things in war-torn Virginia, privates in the Twentieth Massachusetts Regiment, Army of the Potomac. A year later, Bart Crowell came home to Holmes Hole with a leg gone. Peleg Davenport was killed in the terrible Battle of Fredericksburg.

Elisha Smith found glory at Gettysburg. On July 3, 1863, during the storied Confederate assault known as Pickett's Charge, Elisha picked up the fallen flag of his country and, a moment later, was shot in the leg. Writing home to his parents at their farm at the head of the Lagoon, Elisha explained that the regimental color bearer had been killed and that while he, Elisha, had been under no obligation to take up the colors, he had done so anyway and was shot because of it. It was some days before the letter reached the Vineyard; by the time it did, tetanus had found his wound, and Elisha Smith was dead.

I discovered all of this while doing research for a novel about the Battle of Gettysburg. It had seemed unlikely to me that I could create any plausible connection between Martha's Vineyard and the battlefield in Pennsylvania soon to be hallowed by Lincoln, but here it was. Elisha Smith, a Vineyard farm boy, was there at a crucial and desperate moment. And it struck me that, even in that bucolic age predating air travel and fast ferries, the Vineyard was no remote and cloistered island. The Civil War was felt deeply here; islanders went to it—an island boy saw Pickett's fabled Virginians advancing

under their blood-red battle flags. Vineyarders argued about secession, slavery and abolition on the letters page of the *Vineyard Gazette*. Vineyard whalers sailed in fear of Confederate raiders on the high seas.

It has always been like this, I think. In his 1940 memoir, *Country Editor*, Henry Beetle Hough, longtime editor and publisher of the *Gazette*, wrote about the morning World War II began: "Ordinarily the *Gazette* has no concern with outside news, but because this was an occasion which weighed heavily on our hearts and on the hearts of all mankind we wanted to take some notice of it." The *Gazette* may have had no concern with the war, but the Vineyard did, as Tom Dresser amply demonstrates in *Martha's Vineyard in World War II*, written with Jay Schofield and Herb Foster, a veteran of the war. Vineyarders scanned the Atlantic for German submarines. They built a machine gun nest on Peaked Hill. The army mounted a mock invasion of the North Shore, practicing for D-Day. Islanders knew rationing and blackouts. And, of course, island men went to the war.

Tom Dresser, in his growing oeuvre of Vineyard histories, has relied consistently on the files of the *Gazette*, with its steadfast devotion to local news. Yes, Tom's books document island events, but there is that constant interchange with the world at large, that crossover involvement that makes America's history the Vineyard's.

Tom will tell you about the long line of United States presidents who have come to the Vineyard—Barack Obama, most recently, and Bill Clinton before him. They come here to relax, quite obviously, but I think the notion of the Vineyard as a place to escape to me is all wrong, and I think Mr. Clinton and Mr. Obama know that. They know, I think, that this is America—with its sundry ethnicities, its famous and infamous artists and writers, its addiction problems, its environmentalists and climate deniers, its men and women off to war, its rambunctious political partisanship. Would Bill Clinton, that most gregarious of presidents, choose a vacation spot that was truly off the beaten path?

Tom Dresser has found his niche as the Vineyard's resident historian. He once wrote fiction, and I was pleased to have him as a student in one of the writers' workshops I run out of my living room in West Tisbury. What I remember of his novel is its comedic moments, and Tom's writer's eye for the quirks and eccentricities in seemingly ordinary people. It is an eye admirably suited to social history, which is what Tom's fast-multiplying Vineyard books really are. I don't expect a hiatus anytime soon.

—JOHN HOUGH JR.

Author John Hough Jr. lives in West Tisbury. His recent historical novels are Seen the Glory *and* Little Big Horn.

PREFACE

Martha's Vineyard: A History serves as an introduction to Martha's Vineyard for tourists and first-time visitors. It serves as a confirmation for wash-ashores, people not born here but confident that they know their way around. And this book may serve as a subject of discussion and derision for native islanders, who know how it really happened.

The story of Martha's Vineyard is a microcosm of the history of the United States. What happened here reflects what occurred on a national level, with a few notable exceptions.

ACKNOWLEDGEMENTS

Some years ago, Connie Sanborn handed me a paper bag filled with vintage Vineyard photographs, some hers, some by prominent local photographers Basil Welch, Edward Lee Luce and Stan Lair, most unattributed. I'd met Connie because our phone numbers both ended in 1050; her exchange was 696, ours is 693. When Connie's friends called us, we set them straight. We contacted Connie and became friends.

Chris Baer has a wealth of knowledge of Vineyard history. His treasure-trove of Vineyard photos is the best. And he's more than willing to share his abundant fount of information.

Once again, Joyce Dresser, my very supportive wife, took many of the photos of Martha's Vineyard to supplement the story.

The Martha's Vineyard Museum has boxes of photos and reams of paper on Vineyard history.

The archives of the *Vineyard Gazette* stretch back into the mid-nineteenth century and are available on microfiche.

Charles Banks wrote a three-volume *History of Martha's Vineyard* in 1911; Henry Norton collected Vineyard archival tales in a book in 1923; and Art Railton wrote his definitive *History of Martha's Vineyard* in 2006. Gale Huntington's contributions to Vineyard history are legendary.

Martha's Vineyard: A History covers territory my predecessors explored and brings us forward from World War II.

Special thanks to Jaime Muehl, Tabitha Dulla and Dani McGrath of The History Press for all their efforts.

Eldridge Map (1913). Several roads have been added since this century-old map was drawn: County Road in West Tisbury, Barnes Road in Oak Bluffs and Moshup Trail in Aquinnah. Dr. Fisher's Road is clearly marked, as is the proposed electric railway line out to Gay Head. *Map reproduction courtesy of the Norman B. Leventhal Map Center at the Boston Public Library.*

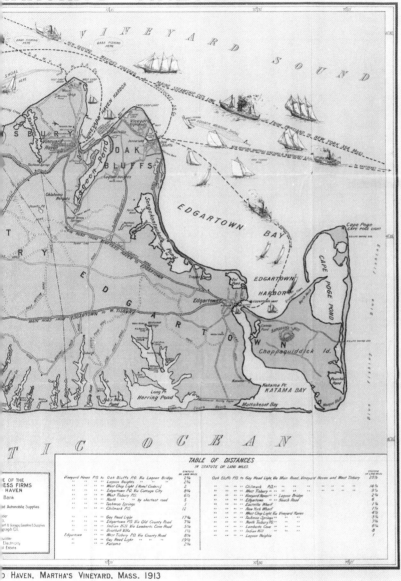

Chapter 1

NOEPE, LAND AMID THE WATERS

Native American Wampanoag tribal members of Gay Head/Aquinnah are proud descendants of Moshup, considered the legendary ancestor of the tribe:

> *The Aquinnah Wampanoag share the belief that the giant Moshup created Noepe* [Martha's Vineyard] *and the neighboring islands, taught our people how to fish and to catch whales, and still presides over our destinies. Our beliefs and a hundred million years of history are imprinted in the colorful clay cliffs of Aquinnah.*[1]

Moshup was the benevolent ancestor of the Wampanoag. He was bequeathed with supernatural power, which he used to help his people.

Moshup created Martha's Vineyard, the Elizabeth Islands, Noman's Land and Nantucket. The Cliffs at Gay Head are sacred ground. Through him, the terrain of the peninsula of Aquinnah can be explained.

How did Moshup create Noepe, which means "amid the waters"? One legend suggests that Moshup "slowly dragged one huge foot, water rushed in and a pool formed behind him. The pool deepened and became a channel and the tide swept in to separate a portion of the land."[2] This explains the formation of Vineyard Sound, the waters that separate Martha's Vineyard from Cape Cod.

Author Dorothy Scoville expands on the legend:

That land became an island separated from Cape Cod by blue water. Soon his footsteps were marked by a chain of small islands, but it was the land that lay ahead which fulfilled Moshop's desire and became the most beautiful island of all. Moshop named this largest island Capawack, or "refuge place."[3]

Off the shore of Gay Head lie underwater boulders, great glacial erratics. This was Devil's Bridge, which evokes another Wampanoag legend. Moshup was building a stone bridge from Gay Head to Cuttyhunk, across Vineyard Sound. As he waded into the sea, he carried a great rock. "Suddenly he was seen to drop the boulder, yell loudly and kick one bare foot in the air. Attached to his great toe was a giant crab which flew through the air to drop with a splash and lie like a small island toward the southwest of Aquinnah."[4] The boulder, some thirty feet below the surface, is known as Devil's Bridge. (It was on this rock that the steamship *City of Columbus* foundered in 1884.) The small island was named Noman's Land, in honor of Chief Tequenomans.

Moshup made an impression on all who knew him. The story goes that an Indian from the mainland washed ashore on Noepe and met Moshup. Upon his return, "he told tales of the great Moshup, who waded into the ocean to catch whales, kept a fire burning to cook his catch and whose pipe smoke was the mist on the Cliffs."[5] This story serves as a teaching tool to cultivate Wampanoag tradition and recount history.

Moshup was protective of his children. Once, he chased away a great white bird that had flown off with his children. The white bird symbolized the sails of a British ship that had captured Indians and sailed back to England to show them off to a curious public. British sailors took Squanto, friend of the Pilgrims, back to England before returning him to America.

Legend has it that Moshup anticipated the arrival of the white man and sought a peaceful coexistence. The story has been told that

in a vision[,] he [Moshop] had foreseen the coming of an unknown, pale skilled people who spoke a strange tongue and sought a new land where they would make their home. They would come one day to Aquinnah and would live there in harmony, for Moshop's children would not lift a hand in anger against a neighbor.[6]

Another Wampanoag legend recounts two lovers' lament. The beautiful daughter of a local chief was named Katama. She fell in love with

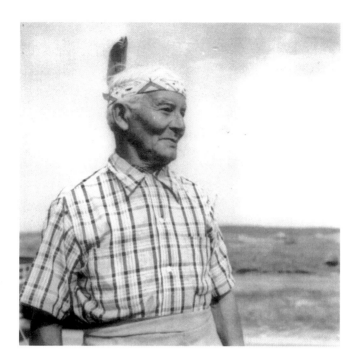

This page: Chief Harrison Vanderhoop standing by the Gay Head Cliffs, circa 1950, selling his wares. Native Americans work the clay from the cliffs into pottery, mold it by hand and dry it in the sun. *Courtesy of the Martha's Vineyard Museum.*

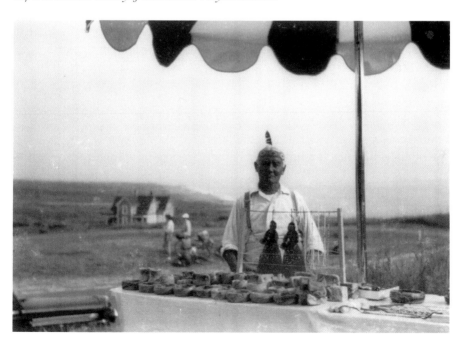

Mattakessett, chief of a neighboring tribe. However, Katama was betrothed to another chieftain, so she could not marry Mattakessett.

Depressed over their inability to marry, Katama and Mattakessett sought advice from Paum-pa-gussit, God of the Sea, hoping he would help them fulfill their love. "Mattakessett drew Katama to him and they embraced. They then plunged into the water and began to swim together down the shining path of Nanepaushat [the Moon God] which would lead them to Paum-pa-gussit's sea kingdom."[7] The lovers swam down the path of moonlight, which shines on the land of Katama, on the Vineyard's southeast shore. If one ventures to South Beach under a full moon, the lovers can be seen swimming off together into the moonlight.[8]

<center>⸻</center>

Martha's Vineyard was not always an island. Some five thousand years ago, the seas rose, separating the land of Noepe from the mainland. Martha's Vineyard became an island.

Archaeologists add to the story: As the glacier inched southward across the Vineyard, it pushed rocks and gravel like a bulldozer along the western side of the island. This became the terminal moraine, the edge of glacial movement. The glacier was more than one mile thick.

As the climate warmed, thousands of years ago, the glacier began to melt. Glacial water ran off toward the sea, carving great gullies in the landscape, evident today in the dips along the Edgartown–West Tisbury Road by the airport. This central section of the island became an outwash plain where icy waters flowed to the ocean.

Deep beneath Martha's Vineyard lies a glacial aquifer, a reservoir of melted glacial ice, which supplies the Vineyard's water system.

Glacial evidence includes kettle ponds beyond Uncle Seth's Pond along Lambert's Cove Road. These three ponds were formed by chunks of glacial ice that broke off and created ponds, now spring fed. Another kettle pond is Dodger's Hole, off the Edgartown–Vineyard Haven Road, which earned its name when swimmers had to avoid, or dodge, snapping turtles.

More glacial evidence is along Lucy Vincent Beach and the Gay Head Cliffs. Eons ago, glaciers forced the land up from the bottom of the sea to form the clay cliffs. Fossils from the ocean floor have been found in the cliffs, including sharks' teeth and prehistoric shells.

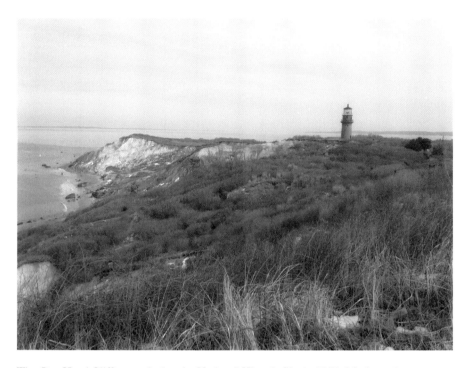

The Gay Head Cliffs were declared a National Historic Site in 1966. Moshup, the benevolent ancestor of the Wampanoag, dreamed he would always remain on Noepe. The Wampanoag believe he will forever protect his people; the fog that enshrouds Gay Head is the smoke from Moshup's pipe. *Photo by Joyce Dresser.*

Because of ongoing erosion, people are no longer allowed to clamber up the cliffs or use the clay for baths or pottery. The Wampanoag, however, retain the right to use the clay for their own purposes.

The Wampanoag is a vibrant tribe of more than one thousand members, although a majority live off-island. Headquarters is a building in Aquinnah where members oversee tribal activities and administer federal funds. Adjacent to the tribal headquarters is housing for Native Americans, built in the 1990s, designed in a manner similar to the original Wampanoag homes: *wetus*. The Wampanoag respect their ancestral heritage. They hold a powwow by the cliffs in September and celebrate Cranberry Day—the end of the harvest—in October. Throughout the year, the

Wampanoag preserve and respect their culture in music, dance and a heritage from days gone by.

Aquinnah (Under the Hill) replaced the town name of Gay Head. Carl Widdiss, of the Wampanoag tribe, believed natives should have a name that reflected their culture. (English seamen named the brightly colored clay cliffs for their Cliffs of Dover.) It took Mr. Widdiss seven years to clear hurdles from the local town meeting to the state legislature, but he accomplished his task, and the name was changed from Gay Head to Aquinnah in 1998.

The story of the Native Americans on Martha's Vineyard differs from Native Americans in the rest of the country. Yes, the Wampanoag were subdued by the white man; however, they were subdued not by the bullet or the ballot but by the Bible.

Wampanoag culture holds that people care for the land in common; the white man demanded individual, private ownership. Wampanoag culture did not conceive of the devil; the white man threatened the Wampanoag with eternal damnation for failure to believe. The Wampanoag lived off the land, wore long hair and minimal attire and practiced a communal life. The white man required short hair, "proper" dress and individual property.

Over the years, the Wampanoag on the Vineyard had to contend with an overwhelming religious force. It proved a battle of wills rather than hostilities between the white man and the Native American. For the Wampanoag, it was a challenge to survive in the white man's society, and survive he did.

In 1987, the federal government recognized the Wampanoag tribe as a sovereign entity, returning some of its land and acknowledging that it was a viable Native American community with the right to self-govern. Today, the Wampanoag tribe of Gay Head/Aquinnah is 1,100 members strong.

WHO WAS MARTHA?

Where did the name Martha came from, you ask?

It began on March 25, 1602, when an Englishman, Captain Bartholomew Gosnold (1571–1607), set sail from Falmouth, England, to the shores of North America.

The goals of his mission were many. Gosnold sought to find the lost colonists of Roanoke, Virginia, last heard from in 1587. He wanted to found a colony, which he eventually did. Tracing the route of Verrazano's earlier exploits in the New World was another goal. And Gosnold sought sassafras, a fragrant bush used to make tea and considered a panacea. Of course, the underlying dream would be to find gold.

"But Gosnold would settle for furs and sassafras, especially sassafras: it was a wonder drug in Europe and obtainable only in the New World." It turns out gout and syphilis responded well to sassafras.[9]

Two of Gosnold's friends were aboard ship: chaplain John Brereton and lawyer Gabriel Archer. Each compiled a report of the voyage. The captain of the vessel, the *Concord*, was also named Bartholomew—Bartholomew Gilbert. The voyage has been characterized as Gosnold's and Gilbert's journey. The crossing took seven weeks, and first landfall was near Portland, Maine. (A nearby town is named Falmouth.)

From the coast of Maine, Gosnold sailed south and anchored the *Concord* in waters off Cape Cod, later also named Falmouth. Gabriel Archer described how they named the elbow-shaped protuberance: "Near this cape we came to fathom anchor in fifteen fathoms, where we took

Visitors to Martha's Vineyard see this sign as they approach the ferry slip in Woods Hole. Bartholomew Gosnold had no such directions. And he had no need to call ahead to request a mooring, as his was the only boat in the harbor. *Photo by Joyce Dresser.*

great store of codfish, for which we altered the name, and called it Cape Cod."[10]

Shortly thereafter, Gosnold led his expedition farther south, by a verdant land of abundant growth and peaceful atmosphere. Grape leaves flourished along the shore. Where there are grapes there should be a vineyard, thought Gosnold, so he named this fair land "Vineyard."

The *Concord* moored by a little island across from the Vineyard, and the crew of thirty-two settled there in the spring of 1602. According to

Brereton's journal, they farmed this island of Cuttyhunk for six or seven weeks, planting wheat, barley, oats and peas. And they built a fort. It looked like a successful colony. "The soil is fat and lusty," reported Brereton. On May 29, he wrote, "We labored in getting sassafras." And again, on "the first of June, we employed ourselves in getting sassafras, and the building of our fort." Furthermore, there were "sassafras trees great [and] plenty all the Island over, a tree of high price and profit," chaplain Brereton reported. Sassafras was on his mind.

Brereton wrote that the natives were "exceeding courteous[,] gentle of disposition and well conditioned." The Indians knew about controlled burns to clear forest undergrowth and allow deer and other wildlife to thrive. They kept the ground cover open and park-like, with low-burning fires, called swidden, or agro forestry. English settlers had no idea why the Native Americans burned the low growth.

Gosnold was eager to return to England. Importantly, the settlement was to be supplied for six months, but the crew had brought supplies for a mere six weeks. That wouldn't work, so Captain Gosnold decided to abandon the Cuttyhunk settlement.

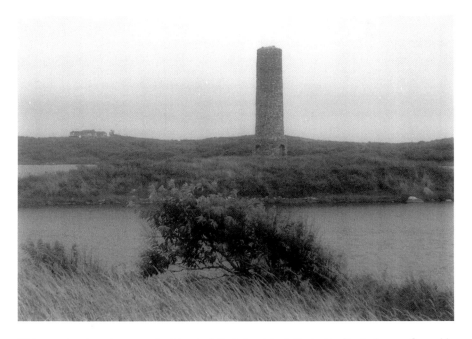

This massive stone tower on the island of Cuttyhunk is dedicated to Bartholomew Gosnold. Gosnold intended to leave some of his crew on this first settlement in the New World; however, they feared he would never return. And he didn't. *Photo by Thomas Dresser.*

Captain Gosnold was homesick; he missed his darling wife, Mary Goldinge, the daughter of Martha Judd. It was for her, more than likely, that he named Martha's Vineyard, since she financed his expedition. He named the Vineyard for his mother-in-law.

On June 18, 1602, everyone clambered aboard the *Concord* and headed home. They reached England a month later.

Mary and Bartholomew Gosnold had two daughters, one named Martha and the other Elizabeth—hence the Elizabeth Islands, which include Cuttyhunk.

The two Bartholomews, Gosnold and Gilbert, returned to England with more than a ton of sassafras. "Sassafras continued to buoy England's investments in the New World, culminating in the Virginia Company's stakes at Jamestown."[11]

(Today, sassafras is a popular ingredient in Creole and Cajun cooking. It is also the key to root beer, once the safrol has been removed. Safrol is used in the drug ecstasy. So there may have been more in Gosnold's adventures than the history books tell us.)

The rest of the story is that Bartholomew Gosnold remained in England for five more years and then sailed westward again. He was captain of the *Godspeed*, one of three ships operated by the London Company, which established a settlement known as Jamestown, named for King James I. This was the first permanent settlement by the white man in North America, and Bartholomew Gosnold was its progenitor or founder. Captain Gosnold never returned to England, however, as he died on August 22, 1607, and was buried by the walls of the Jamestown colony. (His remains were exhumed in 2003; his headstone is part of the historic Jamestown tour.)

Captain John Smith stepped in to lead the nascent settlement and gets credit for founding Jamestown, although Gosnold was the primary promoter.

A final word on Gosnold: the story goes that a fellow named William Shakespeare wrote the play *The Tempest* based on Gosnold's adventures discovering Martha's Vineyard.

THE MISSIONARY MAYHEWS

Some forty years after Gosnold's Vineyard venture, a permanent settlement by a white man took place on Martha's Vineyard. The year was 1642. The man was Thomas Mayhew (1593–1681) from Tisbury, England. The place was Great Harbour, now Edgartown, Martha's Vineyard. Thomas Mayhew originally settled in Watertown, outside Boston, and then obtained a deed for the Vineyard in 1642. He paid forty pounds for Noepe, which included Martha's Vineyard, the Elizabeth Islands, Noman's Land and Nantucket. Some deal.

Mayhew was a missionary, preaching the Calvinist word of God to the Native American population, which numbered more than three thousand in the mid-seventeenth century. Calvinists were Protestants—Congregationalists who feared the spread of Catholicism and preached a doctrine of original sin. They aggressively sought more converts to buttress their Christian orthodox beliefs. Mayhew instituted religious dictums to bring the Wampanoag under his jurisdiction, which meant believing in his Bible—the King James Version.

Mayhew's son, also Thomas Mayhew (1620–1657), was groomed as a successor to the old man and set about furthering his father's mission. He gained the respect of the Wampanoag, who often came to hear him preach and follow his teachings. In 1657, however, Thomas Mayhew Jr. set sail for England to get supplies for the nascent settlement of Great Harbour, as Edgartown was known. Unfortunately, his ship never made it to England, and it was feared that he had drowned. Native Americans were sorely

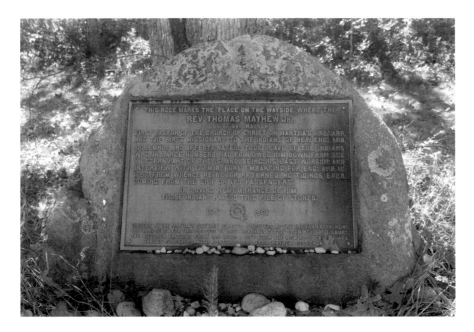

Native Americans worshipped Thomas Mayhew Jr. They gathered to bid him farewell as he sailed off for England in 1657. His ship was lost at sea. This Place by the Wayside is a memorial to him. *Photo by Joyce Dresser.*

distressed and placed small stones on a memorial, now known as Place by the Wayside, in his memory.

Thomas Mayhew Sr. picked up his son's reins and carried on, leading the missionary Mayhews on through the seventeenth century. He encouraged the Wampanoag to adopt the white man's culture. It proved a satisfactory relationship, at least from Mayhew's perspective.

Within a few years, the Society for the Propagation of the Gospel, as supporters of the missionaries were known, translated the King James Version of the Bible into the Wampanoag language, Wopanaak. This was the first time Wopanaak had been codified in written format. The tome, prepared by John Eliot, was published in 1663 by Harvard University and stands as a testament to the Mayhews' intent to inculcate (read: brainwash) their native neighbors. (Today, the Eliot Bible is a source for the rebirth of the Wopanaak language, via the Wopanaak Language Reclamation Project [WLRP].)

"Led by devout missionaries, the early years of the Vineyard were so regulated by the tenets of religion, that, of all the places in the new world, Martha's Vineyard was settled and developed without ever friction arising between the white and Indian people."[12]

Thomas Mayhew and his followers encouraged education, sending young Wampanoag boys to preparatory schools in Cambridge and Roxbury, teaching them English, Latin and Greek. The intent was to have them matriculate at Harvard and then return to the Vineyard to preach the word of the Lord. Harvard even established an Indian College, which operated from 1655 to 1698. (This first brick building on campus was excavated in 2010, and relics of the original printing press, which published the Eliot Bible, were found.)

The New England Company for the Propagation of the Gospel, the funding arm of the missionary movement, paid the tuition for four Native Americans from Martha's Vineyard in 1659. Two of these students, Joel Hiacoomes, son of a Native American who was himself a pastor, and Caleb Cheesheteaumuck, son of the Holmes Hole sachem or native leader, pursued their educations through Harvard. Unfortunately, Joel died when his ship ran aground off Nantucket, and he was hanged by non-Christian Indians. Caleb graduated from Harvard in 1665 but died of tuberculosis the next year. (See *Caleb's Crossing* by Geraldine Brooks.)

(It was well over three hundred years before two more Wampanoag from Martha's Vineyard attended Harvard; they were Tiffany Smalley in 2007 and Tobias Vanderhoop in 2008.)

To demarcate the land of the Wampanoag from the white man, Thomas Mayhew instituted a boundary line, with the Native Americans to the north and the white man to the south. This became known as the Middle Line and can be traced today along Middle Line Road and the Middle Ridge Preserve. The line runs from Waskosim's Rock, on the Chilmark–West Tisbury town line on North Road, to Menemsha Pond.

A great-grandson of Thomas Mayhew, Experience Mayhew (1673–1758), compiled a collection of biographies of Wampanoag on Martha's Vineyard. *Indian Converts*, published in 1727, is key to the study of the melding of two cultures, where the dominant population used the persuasive tool of the Bible, rather than the devastating destruction of the bullet, to convert Native Americans to Christianity. *Indian Converts* showed that the work of the missionaries protected Native Americans from eternal damnation, justifying the Mayhews' missionary efforts.

Over the years, Thomas Mayhew's grandchildren and great-grandchildren assumed the role of the old man, preaching and teaching both the white man and the Indian. And today, descendants of the first Thomas Mayhew are both prevalent and prominent on Vineyard soil.

New York owned the Vineyard? Tell me it isn't so!

Turns out, it's true. Back in 1664, the Duke of York, who later became King James II, struck a deal whereby the Colony of New York became the titular owner of Martha's Vineyard. Thomas Mayhew Sr. was named, not elected, governor for life. He was required to pay New York two barrels of codfish per year for the right to oversee the Vineyard. In return, he was the final arbiter for all matters relating to executive, legislative and judicial issues on the Vineyard.

New Yorkers were intent on leaving their imprint. Busily, they named their counties: King's County, Queen's County and Duchess County, and when the Vineyard came along, it became Dukes County. Today, Martha's Vineyard and the Elizabeth Islands constitute the County of Dukes County.

Not content with that, the New Yorkers renamed the town of Great Harbour for the (presumed) future king of England: Edgar (1667–1669), son of King James II, who was already the Duke of Cambridge. (Their first choice for a new name was Jamestown, but that had already been taken.) So Great Harbour became Edgartown. Unfortunately, little Edgar died before he could appreciate that a Vineyard town bore his name. And he never became king of England. (As far as we know, the Vineyard's Edgartown is the only one in the world.)

King Philip's War raged across southern New England in 1675–76. Metacomet, known as King Philip, was a grandson of Massasoit, the Native American who befriended the Pilgrims in 1620. Metacomet was outraged at the way Native Americans were treated on the mainland and went on a rampage, slaughtering eight hundred colonists across Massachusetts, Connecticut and Rhode Island.

It is of particular note that the Wampanoag of Martha's Vineyard did not participate in these bloody attacks on colonial settlements. The three hundred Native American families of Martha's Vineyard respected the passive role of the missionary Mayhews and refused to support the devastation wrought against the white man. King Philip was killed, along with three thousand mainland Wampanoag.

After sixteen years under the rule of the Colony of New York, in 1680, Martha's Vineyard was traded back to the Colony of Massachusetts (for a player to be named later). Within two years, in 1682, Thomas Mayhew Sr. died, his name firmly established as a Vineyard dynasty.

Over the years, the white man appropriated more and more of the land of the Wampanoag. Native Americans were herded into three

Vineyard settlements: the island of Chappaquiddick; Takemmy, known as Christiantown; and the most heavily populated, Gay Head. Control of the land was the ultimate goal of the settlers, although the initial intent of the missionaries was to save the souls of the natives.

The population of the Wampanoag dropped due to their inability to combat the white man's diseases. The initial population of 3,500 Wampanoag at contact in 1642 had dropped to 800 by 1720 and a mere 300 by 1770. The presence of the white man was detrimental to the Wampanoag.

Even as the white man sought to control the natives and convert them to Christianity, settlers were making the land their own. In 1665, Benjamin Church constructed "the first gristmill in the town of West Tisbury. On the Tiasquam River, which is actually more like a brook, he built two dams and made a pond in the natural valley behind the mill. This pond, about three acres in size, was fed constantly by the Tiasquam River."[13]

Mayhew's Congregationalists faced competition. In 1693, Baptists started preaching in a church in Gay Head, which today is the oldest Native American church in the country. The Congregational Church, Mayhew's mission, ended its run in 1836. Mayhew's Congregationalists had fallen out of favor by the time the fifth generation of Mayhew missionaries, Zachariah Mayhew (1718–1806), died. Baptists preached in English and catered more efficiently to the wants and needs of the Native Americans than had the missionary Mayhews.

REVOLUTIONARY ECONOMICS AND WAR

L ife on a small island off the coast of Cape Cod in the early eighteenth century was anything but easy.

For years, farmers had struggled to clear their land of myriad rocks deposited by glaciers across the landscape. At first, the rocks were gathered into piles to allow farmers to plant crops. Later, the farmers built stone walls along property boundaries, which kept wild animals out and tame animals in. Today, looking at the stone walls along the fields and hills of Chilmark, one can appreciate the effort, all done by hand, that went into building them.

We know that the Allen Sheep Farm on South Road in Chilmark was acquired by Tristram Allen's family in 1762. Tristram married Clarissa Mayhew in 1791. The Allen farm is still a sheep farm today; it offers an array of organic wool products such as sweaters and blankets available for purchase, as well as a magnificent vista of the South Shore.

A large percentage of the colonial Vineyard economy was dependent on sheep, which produced both wool for clothing and lamb for sustenance. Sheep flourished on the rolling hills that predominate the Chilmark landscape. More than one tourist has compared the hills of Chilmark to those of Vermont.

Challenges in herding sheep led to the construction of sheep pounds or stone pens to hold lost sheep or cattle until the owner could be found to regain possession of his errant ruminant—and pay a fine. Three pounds are visible today: one on State Road in Aquinnah, beyond the town offices; a

This page: The story goes that sheep don't like to be fenced in, so builders of stone walls left cracks and crevices between the rocks so sheep could peek out. We're not sure of the truth of this legend; perhaps it's just a sheep's tale. *Photos by Joyce Dresser.*

second on State Road beyond the bridge by Stonewall Pond; and a third on North Road, across from Great Rock Bite. These holding pens, or pounds, were the precursors to today's dog pound.

For sheep to thrive, they need salt. In the eighteenth century, saltworks were built along the shore. Large pans were set where, according to Connie Sanborn,

> *salt was manufactured by the ancient method of evaporation of sea water. They were in existence in 1840 and others at or near the herring creek were erected at least 20 years previously.*
>
> *There were at least four of them* [saltworks] *between the Head and West Chop and others all around the Island. The construction of the machinery to separate the salt from the ocean water was very simple. A long vat made of wood—I think about 25 or 30 feet long and 5 or 6 feet wide—was placed about 3 feet above ground. The vat had a sliding cover that could be drawn over it in case of rain or snow. Then the sea water would be pumped into the vat to a depth of about two inches and allowed to evaporate leaving pure white salt that was used by the inhabitants.*[14]

Were there slaves on Martha's Vineyard?

We noted earlier that Martha's Vineyard could be a Petri dish for what happened across the country, and that is evident in the issue of slavery.

Slaves from Africa were brutally captured and forced aboard ship, chained in the holds of slave trader vessels on the infamous Middle Passage. Once slave ships landed in the American colonies, the Africans were sold off. Although we have not obtained seventeenth-century records of slaves on Martha's Vineyard, we can presume that slaves were here.

The first slave transaction we uncovered on Martha's Vineyard occurred on August 24, 1703, when Samuel Sarson, a grandson of Thomas Mayhew, sold an African American woman for twenty pounds. No name or age was listed on the invoice. Another slave transaction describes "one neager garll" about seven years old. Her name was Rose; she was presented as a gift from Thomas Jernegan to his son.

A man from Falmouth sold a ten-year-old Negro boy named Peter to Zacheus Mayhew on June 19, 1727, for 150 pounds of gold. Ebenezer Allen, an up-island innkeeper, owned slaves valued at 200 pounds in 1734. It is of interest that Jane Cathcart, of Chilmark, granted her slave,

Ishmael Lobb, his freedom in 1741. Slavery was part of Vineyard life in the eighteenth century.

The population of Martha's Vineyard in 1765 totaled 2,400 people. Of those, 46 were African American—less than 2 percent. So there were slaves and free African Americans, as well as a dwindling population of Wampanoag.

An intriguing story of Vineyard slaves involves Rebecca, a woman from Guinea in West Africa. Rebecca—or Beck, as she was known—was enslaved by Colonel Cornelius Bassett on his farm on North Road, today identified by the windmill. Rebecca was a slave but married Elisha Amos, a Wampanoag known as Jenoxett, who owned property by Roaring Brook, farther north on North Road. When Jenoxett died, Rebecca inherited his property; hence, she was both a landowner and a slave. For an eighteenth-century woman, that was quite a feat.

In 1783, slavery was challenged in the Massachusetts courts in a case tried by Levi Lincoln of Worcester. Quock Walker, a slave, sued for his freedom. Lincoln argued that the Massachusetts constitution, written in 1780 by John Adams, stated, "All men are born free and equal." The judge declared Walker a free man. Henceforth, if a slave filed a lawsuit, there was a good chance that he would be declared free in Massachusetts.

And so it was that Rebecca and her children were freed in 1783. Her daughter Nancy, born in 1776, became free at the age of seven.

Nancy did not have an easy life. Known as Old Nance, she survived on the edge of poverty. Nancy's grandson William Martin became the first, and only, African American whaling captain on Martha's Vineyard. Thus, within four generations, a descendant of a slave reached the highest economic station of the nineteenth century.

As the abolition movement expanded, Massachusetts became a haven for runaway slaves until the institution was outlawed with the Emancipation Proclamation in 1863.

War—Vineyard style.

Martha's Vineyard, as well as Nantucket, chose not to take sides in the American Revolution between Great Britain and the colonies. Although the Vineyard declared itself neutral, war came anyway.

One Vineyarder died on the shores of Martha's Vineyard during the Revolution. Sharper Michael was a slave of Zacheus Mayhew. The *Cerberus*,

a British man-of-war off Gay Head, fired on a Vineyard ship in 1777. Sharper Michael and other locals held the ground atop the cliffs and fired on the *Cerberus*. The British set fire to the American ship, sank it and shot randomly at the cliffs. Sharper Michael was struck and died—the first, and only, casualty of the Revolution on Vineyard soil.

Other than this, the Vineyard was not actually attacked during the war, yet patriotic fervor was not dormant. On April 19, 1778, the British ship *Unicorn* limped into Holmes Hole, as Vineyard Haven was known. "Now his Majesty's ship was in want of a new spar, and as the only stick of timber on the island that would answer for the purpose, was the liberty-tree, down it must come."[15] The British intended to appropriate this tall pole to use as a mast.

Three young girls—Parnell Manter, Maria Allen and Mary Hillman (aka Polly Daggett)—"by means of augurs, pierced it [the liberty pole] with numerous holes, which they filled with gunpowder; then they cautiously applied the match and the emblem of liberty was shattered in many pieces."[16] This incident deprived the Brits of their needed spar and planted the young women firmly in the annals of history, at least on Martha's Vineyard.

Later that same year, on September 10, 1778, Major General Charles Grey (1729–1807) led a flotilla of British ships into Holmes Hole. The British armada was first spotted by the slave Rebecca from her vantage by Great Rock Bight. "The sight must have been a thrilling one—two score vessels including twelve ships of the line. It amazed and terrified the peaceful people, now removed from participation in the war and behaving as neutrals. No one knew whether it meant destruction, or a fleet seeking anchorage."[17] The armada consisted of forty ships bearing four thousand troops.

Colonel Beriah Norton, of Holmes Hole, led a committee of local citizenry to ascertain what Major General Grey wanted. In Norton's words, "I waited on him on board ship & agreed to deliver him 10,000 sheep & 300 head of Cattle," or oxen. "Milch cows" were excluded.

Grey declared that he came in peace but demanded that sheep be shepherded aboard his ships, to be transferred to Newport, Rhode Island, where the British intended to spend the winter of 1778 (while George Washington and his men starved and froze in Valley Forge, Pennsylvania.)

Thousands of sheep and a few hundred head of cattle were herded aboard ship. One woman defied the British by forcing her cow into her attic, saving it from the fate of fellow bovines.

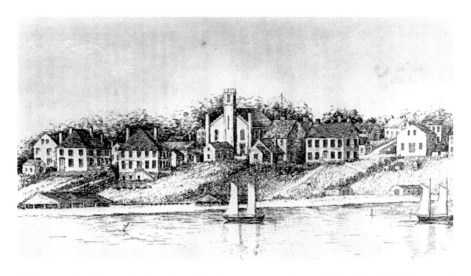

This engraving depicts the shoreline of Vineyard Haven. The British raid of 1778 destroyed several small ships and the saltworks in Holmes Hole, as Vineyard Haven was then known. *From the collection of Connie Sanborn.*

The three Vineyard towns met the quota demanded by the British:

Chilmark: 3,903 sheep, 106 cattle

Edgartown: 3,919 sheep, 112 cattle

Tisbury: 2,752 sheep, 97 cattle

Total: 10,574 sheep, 315 cows, plus 52 tons of hay

Martha's Vineyard was destitute. And although the British promised payment for the raid, such reparations never occurred. The hardship caused by Grey's attack paralyzed the Vineyard for decades.

Interestingly, in the late eighteenth century, a number of freed African Americans made their way to Gay Head and intermarried with the Wampanoag. This melding of two cultures proved a safety net for recently freed slaves who were welcomed by the Wampanoag. A common bond was forged between the two races, at least in Gay Head.

John Saunders's story offers grim closure to his incarnation as the first Methodist preacher on the Vineyard. Although a freed slave, Saunders arrived in Holmes Hole in 1787 aboard a ship from Virginia, concealed beneath a mound of corn. He and his wife, Priscilla, shared the word of

God with African Americans who lived in the Farm Neck/Sengekontacket section of Oak Bluffs. Saunders stood on Pulpit Rock with his flock in the swale before him and preached. (The African American Trail believes Pulpit Rock is on the Land Bank road; another likely site is adjacent to a nearby Native American burial ground.)

After years of co-preaching with her husband, Priscilla died. Saunders sought comfort from a Native American woman, which proved his undoing. John Saunders met and married Jane Diamond, a Wampanoag woman, and moved in with her on the island of Chappaquiddick. There, he met an untimely end, as members of the tribe did not approve of the marriage. Saunders was slain.

As the country slipped into the 1800s, the issue of slavery generated further attention. Escaped slaves sought freedom in Massachusetts. The abolition movement gained momentum.

Stories of runaway slaves have filtered down through the years. A memorable account was that of Randall Burton, who escaped bondage in 1854 in Jacksonville, Florida, and stowed aboard a merchant ship, the *Franklin*, which moored in Vineyard Haven Harbor. Burton obtained a small boat and rowed ashore. He made his way to Gay Head and found safety in a cranberry bog, protected by the local Wampanoag.

Two women found Burton, dressed him in women's attire and raced off by carriage, heading for Menemsha. The local sheriff sought to intercept them, as the Fugitive Slave Act of 1850, rewritten with stricter enforcement measures than the original Act of 1792, made it a crime to aid and abet a runaway slave, even in freedom-loving Massachusetts. The two women hastened off with Randall Burton, pursued by Sheriff Lambert.

Passage was secured aboard a sailing vessel bound for New Bedford; Burton was hustled aboard. Sheriff Lambert was stymied.

Randall Burton was ferried across Vineyard Sound to New Bedford and spirited off to Canada via the underground railroad. In a coda laden with sarcasm, the *New Bedford Standard* thumbed its nose at the Vineyard sheriff, writing, "We are very happy to say that the fugitive in question arrived safely in this city, and is now in a place of safety." The *Vineyard Gazette* eagerly reprinted the statement. So goes the tale of the legendary Randall Burton.

THAR SHE BLOWS

L ong before the white man arrived on the Vineyard, Native Americans conducted whaling exploits in small boats along the coast. They used whales for food, clothing and tools. When the white man discovered this bountiful harvest right offshore, whaling became a singular focus of financial gain, primarily—or perhaps we should say, exclusively—for the captain and officers of a whaling ship. Lowly seamen could expect $1/150$ of the proceeds after a year or more at sea.

The birth of the whaling industry was a natural evolution for the white man. The Indians showed them how to capture the massive mammals. As whaling developed, Native Americans were enticed to join whale ships as boat-steerers or harpoonists, the men who speared the whales.

The concept of whaling was simple: Men would scour the seas until a whale was spotted by the lookout, high on the mast, who sang out, "Thar she blows!" referring to the spouting whale. They would quickly lower a small boat, equipped with a harpoon-bearer. Once the whale was speared, a line ran out as the whale dove and, hopefully, resurfaced. Then the crew would kill it.

Historian Henry Norton stated that the schooner *Lydia* was the first whale ship out of Edgartown in 1765.[18] Whaling expanded in the nineteenth century as Edgartown became a prominent whaling harbor. As whales were overhunted in the Atlantic, the whale ship *Apollo*, led by Captain Jethro Daggett, set off into the Pacific in 1816, expanding the horizon of the whaling industry.[19] (See story on Uncle Jethro on page 41.)

Harvesting a whale was work but not as dangerous as harpooning. Blubber was carved from the carcass and hoisted aboard ship, where it was boiled in cauldrons, such as the one in Edgartown's Cannonball Park. Singing sea shanties made the work seem easier. Blubber was boiled down to oil, though the danger of fire from boiling blubber was real. The cooper assembled barrels to store the oil, and the barrels were lowered into the hold below deck. This process was repeated until the captain determined they had sufficient oil to make it a worthwhile venture.

Key to whaling was a capable crew. While many sea captains hailed from Edgartown, often the crew was a mismatched collection of seamen, willing to spend months or even years at sea with little promise of a positive return. Often, a whale ship visited the Azores or Cape Verdean Islands in search of crew. Once able-bodied sailors were enticed aboard ship and underwent a sailing voyage, it was not uncommon for them to settle in Edgartown. Hence, the whaling industry was instrumental in enticing people to the Vineyard, adding the element of Portuguese heritage. Over the years, many people migrated from the Azores to the Vineyard.

In the early 1800s, a whaling expedition would be accomplished in a matter of months; by the late 1800s, it took a matter of years and involved sailing around Cape Horn to hunt whales in the vast Pacific.

A prominent entrepreneur, the wealthiest nineteenth-century businessman of Martha's Vineyard, was Dr. Daniel Fisher of Edgartown. Yes, he was a physician, but he made his name, and his fortune, in whale oil. He was the original oil magnate, the middleman who bought barrels of oil from whaling ships and then sold the oil to lighthouse keepers along the coast.

Fisher was born in Sharon, Massachusetts, in 1800; came to the Vineyard in 1824; and served in town offices. In 1829, he married Grace Coffin, whose father provided Fisher with a dowry equal to the wife's weight in Spanish silver dollars. Dr. Fisher became a prominent profitable physician and surgeon.

Dr. Fisher purchased a spermaceti candle works factory in the 1830s. (A large sperm whale produced nearly five hundred gallons of sperm oil.) "Fisher modernized the oil refinery and candle-making operations and expanded the storage capacity for whale oil. The large whale oil storage warehouse allowed Fisher to purchase oil in large quantities at a market

discount. Fisher's oil storage warehouse was so large that it was colloquially known as "Dr. Fisher's Fort." At one time, Dr. Fisher's spermaceti whale oil candle-making factory was the largest in the world.[20]

By 1850, Dr. Fisher's Fort was producing sixty tons of candles and thousands of barrels of refined whale oil annually. Fisher donated streetlamps to the town, with the proviso that it purchase his whale oil. (Reproductions of his lamps line downtown Edgartown.) He built a road to West Tisbury (see Eldridge's 1913 map) to cart wheat from his fields for hardtack for his workers. Sections of the Dr. Fisher Road are still extant. He was ingenious, inventive and illustrative of forward-looking entrepreneurs of the era.

Dr. Fisher built an elaborate estate in 1840 on Main Street, Edgartown, adjacent to the old Whaling Church. It is in the care of the Preservation Trust and is opened for Martha's Vineyard Hospice during its fundraising bazaar for Christmas in Edgartown.[21]

One whale man described his early years: "If correctly informed, I was born in a small hamlet, on the outskirts of the village of Edgartown."

Uncle Jethro Daggett explained that "Edgartown, the shire town of the County of Dukes, [is] situated on the southern extremity of the, to-day, far-famed island of Marthas [sic] Vineyard." He went on to describe "the principal occupation of its inhabitants [as] being the catching of fish, of the different kinds and dimensions, with which its neighboring waters were abundantly supplied. Here and there might have been seen among its places of business the shop of a Hatter, Blacksmith and Cooper."

Nineteenth-century Edgartown was a bustling community:

> A number of wharves graced the shores of the inner harbor (which is not boasting to say is one of the finest on the American continent) as many a sailor has found to his great joy, when enabled to drop anchor there after buffeting the bitter blasts of a wintery storm.[22]

And Uncle Jethro described the capture of a whale:

> Two boats lowered, which were commanded by the Captain and Mate. The captain's boat got fast, and instead of killing the whale himself, as he should, he let the boatsteerer throw the lance which was boned, the whale

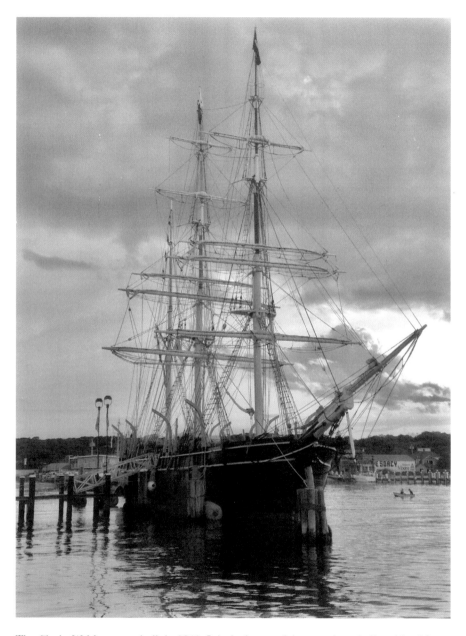

The *Charles W. Morgan* was built in 1841. It is the last surviving wooden whaling ship. After a five-year restoration program, the *Charles W. Morgan* sailed along the New England coast in the summer of 2014. Edgartown, New Bedford and Nantucket provided the bulk of whaling ships, crew and captains. It was from these three harbors that the majority of whale ships sailed from the mid-1700s to 1900. *Photo by Joyce Dresser.*

rolled, the line came taut, and the boat was capsized. The mate immediately fastened, and soon the whale was spouting thick blood. We felt better as we beheld his corps [sic]. Towed him to the ship and went to work cutting him in. It was now the first of March, 1818; nine months from home, and we hadn't taken oil enough to burn in the binnacle lamp.[23]

From these whaling adventures, Uncle Jethro reported that the *Apollo* returned with one thousand barrels of oil, "sold at the rate of thirty-eight cents per gallon for the sperm, and twenty-two for the right whale. My wage after settling the voyage amounted to seven dollars per month; was absent twenty-two months, and I was perfectly satisfied that I had seen all the experience I designed in the whaling business."[24]

Whale oil was used for illumination. Whale oil was more efficient than candles or an open flame, yet oil was limited by the number of whales available.

Many tales of whales have surfaced over the years. In 1820, a whale flipped its tail and sank the *Essex*. The crew members made their way across the Pacific in small boats, reduced to cannibalism. (See the play *The Essex*.) Herman Melville, a New Yorker who sailed out of New Bedford/Martha's Vineyard aboard the *Acushnet*, used the story of the *Essex* for his book *Moby Dick*, aka *The Whale*. (Melville ran into Nathaniel Hawthorne by chance in a storm on a mountaintop in western Massachusetts in 1850. While waiting out the storm, Hawthorne encouraged Melville to pursue the story. It was published, although Melville was not recognized for the work during his lifetime.)

Cynthia Riggs, of West Tisbury, shares stories of her forebears, whale men who sailed the Pacific in the mid-1800s. Her great-great-grandfather Captain Henry Cleaveland was captain of the whale ship *Niantic*. He brought miners to California. His son, James, also a captain, met Mary Carlin of Australia and married her in the Sandwich Islands (now Hawaii). Mary sailed with James and gave birth to two daughters during the voyage. Later, James Cleaveland was captain of the *Mary Wilder*; he escaped an attack by the CSS *Alabama* during the Civil War. Cynthia Riggs lives in the Cleaveland House, built in 1750, in West Tisbury.[25]

Laura Jernagan, of Edgartown, spent her formative years aboard ship and kept a diary in the 1860s. Her journal recounted gams (get-togethers on the high seas), as well as whaling adventures.[26]

William Martin, great-grandson of the slave Rebecca, rose from cabin boy to pilot to captain of his own whale ship and led several successful voyages in the late nineteenth century. He was the only African American whaling captain of Martha's Vineyard. Martin's house is on Chappaquiddick. He

and his Wampanoag wife, Sarah Brown, marked their fiftieth wedding anniversary in 1907. They had no children, so the line of descent from Rebecca, the African slave, died with them. They are buried in the Chappaquiddick cemetery, overlooking Cape Pogue.

The demise of the whaling industry occurred at the end of the nineteenth century. This was due to the discovery of oil in Titusville, Pennsylvania, in 1859, which meant serious competition for the whale oil industry. During the Civil War, Confederate raiders attacked whalers and Union forces sank old whale ships to blockade Confederate harbors. And Thomas Edison invented the electric light bulb in 1879.

We break from whale tales to explore steamship service to Martha's Vineyard in the 1800s.

It was the unlikely named *Marco Bozzaris* that first brought passengers to Martha's Vineyard. The *Marco Bozzaris* ferried over 200 people from New

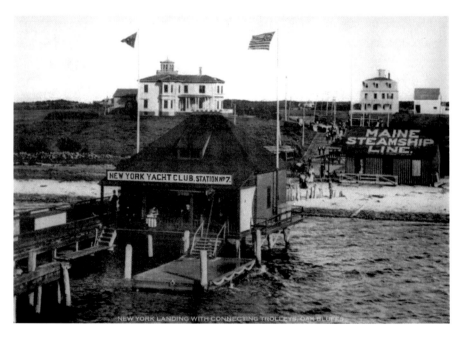

As whaling died out, Edgartown evolved into a tourist mecca. The New York Yacht Club's members first sailed to the Vineyard in 1858, an invitation that was repeated over the years. The Yacht Club had its own pier on East Chop in Oak Bluffs. *From the collection of Connie Sanborn.*

Bedford to Martha's Vineyard, along with a brass band, steaming into Edgartown Harbor in 1830. Then the *Marco Bozzaris* transported 150 people from Nantucket to the Vineyard. Neither island has been the same since.

Within a couple years, the paddle-wheeler *Telegraph* "stopped regularly at Vineyard Haven." Built in 1832, it was deemed "an acceptable ice breaker." Passengers on the *Telegraph* would stand at the stern of the vessel as it approached an ice floe; "they would then move forward as a group to add their weight to that of the ship's bow in breaking the ice."[27]

Besides breaking ice, "a unique feature of the *Telegraph*'s service was her cabin boy who would often sit at the entrance to the saloon in rough weather and play his violin, the strains of his music hopefully soothing afflicted passengers."[28]

During the early years of Vineyard steamship service, the *Eagle's Wing* exemplified lavishness with a dining saloon, staterooms, berths and a sign that read, "Ladie's Cabin," which never got corrected, even after numerous complaints.

WHA'S THAT?

Jonathan Lambert was born in Barnstable, Massachusetts, in 1657. His ancestry can be traced back to England, specifically to County Kent, east of London. Lambert and his wife, Elizabeth Eddy, moved to Martha's Vineyard in 1694, when he purchased sixty acres of waterfront land on the north shore for seven pounds. Today, a cove, a beach and a road bear his name.

Lambert was a carpenter and a farmer. And he was deaf. He and his wife raised seven children. He died in 1738. In his will, his property was left, in part, to two of his children who were also deaf: Ebenezer and Beulah. Jonathan Lambert is considered the progenitor of the deaf population on Martha's Vineyard, which lasted from the seventeenth century until the mid-twentieth century.

In the small rural village of Weald, in County Kent, England, a genetic mutation, the recessive gene for deafness, occurred. Weald is an isolated sheep-raising and farming community where people typically married within their immediate cohort. A number of residents of Weald journeyed to America together in 1634 and settled first in Scituate and then in Barnstable, eventually moving to Martha's Vineyard. They moved and settled as a cohesive cluster.

Most people in the seventeenth century married within their communities and continued to live locally. The people from Weald, County Kent, kept viable the recessive gene for deafness. "Families stayed in the same village, often even the same house, for two or even three centuries."[29] And there was limited "new blood" in the community.

The result was that most marriages occurred between people who were related. Because it was not illegal to marry one's cousin, by the mid-1800s, 85 percent of second cousins married a cousin. In Chilmark, where descendants of Jonathan Lambert predominated, this led to a high number of deaf infants. "The geographic, and resulting cultural, isolation, and the way it showed up in the society—mainly by intermarriage—had preserved the recessive gene that caused the recurring deafness on Martha's Vineyard."[30]

Deafness was caused by "a mutant gene for deafness with subsequent inbreeding by the carriers of that gene, first in the Weald and then on the Vineyard."[31] The preponderance of the recessive gene for deafness surfaced time and again due to endogenous marriage, or inbreeding, in the tight community. An autosomal recessive gene (pairs of chromosomes) caused the inherited deafness.

The community was unaware of the recessive gene for deafness. Nor did it bother them that so many people were deaf. "In 1854, when the incidence of deafness on the island peaked, the national average was one deaf person in 5,728; on the Vineyard, it was one in 155. In Chilmark, it was one in 25, and in Squibnocket, a section of Chilmark, one in four babies born in the mid-nineteenth century was deaf."[32]

In 1840, fourteen people were born deaf; in 1870, only one person was born deaf. By 1900, fifteen people in the community were deaf; that number dropped to four in 1925. The last of Chilmark's deaf people died in 1952.

The community embraced the deaf, neither singling them out nor ignoring them. The deaf were simply part of the population. One local woman remarked, "They weren't handicapped. They were just deaf." Jamie Kageleiry wrote, "Not being able to hear was more akin to being left-handed."[33]

Nora Groce reported, "There seems to have been few or no social barriers placed on deaf islanders." And everyone was "included in all aspects of daily life from their earliest childhood."[34] It was quite evident that "deafness was not perceived as a handicap."

———

Everyone in Chilmark learned sign language. That was key to the inclusive nature of the situation: "The ease with which the first deaf Vineyarder was integrated into the population seems to indicate that a fairly sophisticated sign[ing] system was already in place. It seems logical to conclude that the language can be traced back to the Kentish Weald."[35] So the people of

Kent brought not only their goods and chattel from England but their sign language as well.

A report in the *Boston Sunday Herald* in 1895 stated, "In the stores, on the farms, and up the creek, Martha's Vineyard sign language was the only language that everybody knew."[36] Signing became an integral part of the local community. With so many deaf people, the only way to communicate with everyone was by signing. As more visitors came to the Vineyard, locals used sign language if their intent was personal.

The report continued, "The spoken language and the sign language will be so mingled in the conversation that you pass from one to the other, or use both at once, almost unconsciously." And Groce adds, "Undoubtedly, the bilingualism of the community made marriages between hearing and deaf members more common than it was off-island." Town records indicated that deaf people not only took care of themselves economically, as fishermen or farmers, and participated in politics, but they were also fully integrated into the community.

One person recalled, "There were all these people sitting around the [Chilmark] store, you know, at night, the way it is with country stores. And there was no noise, there wasn't a sound, but they kept smiling and chuckling, so we were very much surprised and finally we realized that they were deaf and dumb."[37]

Another person recalled the anger that erupted over a horse trade, as retold by Nora Groce: "She didn't want that horse traded, and boy, did she scream at me [in sign language]! The whole neighborhood still remembers that fight she had with her sister-in-law down here on the road. Her sister-in-law could hear fine, but she could sure hold her own fighting in the sign language too."

In the 1880s, Alexander Graham Bell was one of many to investigate deafness. He was an advocate for deaf education, because his wife was deaf, Bell sought an answer to the preponderance of deaf people on the Vineyard. His suggestion that it was related to genealogy was not far afield.

Richard Pease, an Edgartown genealogist, worked with Bell to record local family genealogies in order to trace deafness. After two years of study, Alexander Graham Bell presented his findings, entitled "The Deaf-Mutes of Martha's Vineyard," in the American Annals of the Deaf in 1886.

"Nearly all the deaf-mutes of the Vineyard are natives of the little town of Chilmark," Bell's report read, "a scattered hamlet having in 1880 a

population of nearly five hundred people, of whom twenty were deaf-mutes, which is in the proportion of one deaf-mute in twenty-five inhabitants. If this proportion held good for the whole country we should have in the United States no less than 2,000,000 deaf-mutes!"

Bell advanced several causes for deafness, from heredity to "the geological character of that portion of the island, which is undulating." The report concluded:

> *Dr. Bell showed by elaborate and ingenious genealogical charts the curious relationship by blood and marriage that exists among all these families, and the probability, though not yet absolute certainty, of their being descended from common ancestors belonging to the families containing deaf-mutes who resided in Chilmark and Tisbury over two hundred years ago.*

Thus, he came close to concluding that deafness was caused by an inherited gene.

Nevertheless,

> *these intermarriages persisted and the deaf population of Chilmark and the rest of the Vineyard continued to propagate. It would have kept growing if not for the growth of deaf education on the mainland. As deaf Vineyard children attended schools off-island, they tended to settle off-island, married mainland mates, and gradually the deaf Vineyard population died out.*[38]

The first school for the deaf was founded in Hartford, Connecticut, in 1817. "The island children brought with them their Vineyard sign language, and their colloquialisms blended into the formal sign being taught. The result evolved into the American Sign Language."[39] Jamie Kageleiry suggests that "it was sending the deaf children off-island to school that ended the Vineyard's genetic isolation."

———

Interestingly, a number of people from Martha's Vineyard relocated to the Sandy River Valley area of Kennebec County, Maine. A similar situation arose with a number of deaf babies; sign language again proved effective in integrating the deaf into their community.

Vineyard historian Gale Huntington knew several deaf people, "and almost without exception the deaf-and-dumb were valuable members of the community."[40] Jared Mayhew was a farmer, Ben Mayhew was a fisherman, George West and his wife were both deaf and one of the Wests' three children was deaf. Even the babysitter Huntington hired for his daughter Emily was deaf. (She signed to Emily, who pretended not to understand, which particularly annoyed Huntington.)

"Everyone in Chilmark was identified by a sign for that was an easier and quicker way than spelling out the person's name."[41] Places were also identified by sign. New Bedford was indicated by pointing toward the ferry slip and then holding one's nose, indicating the smell of whale oil.

Nora Groce reported that "several informants remembered that some of the less educated hearing people would occasionally bring a newspaper or legal document to their deaf neighbors to have it explained."

Jane Slater of Chilmark wrote the town column for the *Vineyard Gazette*. In February 1999, she wrote, "Some us still remember having deaf friends and relatives in Chilmark and the ease with which we communicated with them." She commended Joan Poole-Nash for her "extensive knowledge of the Chilmark deaf folk," documented in *Yankee Magazine* in an article entitled "The Island That Spoke by Hand."

In 1979, Joan Poole-Nash brought a team from the New England Sign Language Society to film local residents reciting the alphabet and commenting on life in sign language.

Joan filmed her ninety-year-old great-grandmother, Emily Howland Poole, who wasn't deaf. Joan observed, "'They remember all the bad signs. And everyone one of them remembers the sign for codfish.'" The people in the film recall deaf and hearing residents gathering at the local store, communicating by mouth and hands in a flurry of activity. "Yet they lived full lives, grew up, were happy or unhappy, farmed well or farmed poorly, married well or badly, and got on or didn't get on with their neighbors like anybody else. They just spoke with their hands."[42]

One fellow observed "that deaf men who fished off Squibnocket caught as much codfish as anybody else. They just couldn't hear the codfish complain, that was all."

Gale Huntington described the eventual decline of the deaf population on the Vineyard. "With new blood from off-Island, and even from down-Island, the genetic fault that caused hereditary deafness vanished after surviving in Chilmark for the better part of 300 years."[43] The last deaf islander passed away in 1952.

Nora Groce concluded, "The most important lesson to be learned from Martha's Vineyard is that disabled people can be full and useful members of a community if the community makes an effort to include them."[44]

Thomas Hart Benton, the regionalist, painted Josie West in 1926. Polly Burroughs described West's "large hands, so characteristic of New England farmers, hands which not only fed his family, but whose quick and flexible fingers were George's [Josie's] only communication with the world around him."[45]

Josie West died in 1945. Katie West, Josie's sister-in-law, died in 1952. The last of the Chilmark deaf community had passed on.

It is of interest that another genetic anomaly occurred in Chilmark. Lucy and Sarah Adams were born in 1861 and 1863, respectively, the eldest of six siblings. Lucy and Sarah were small children and small adults, never topping four feet.

As schoolchildren, they were asked to play "baby" at recess. After graduation, they were befriended by General Tom Thumb, aka Charles Stratton, and joined the Barnum & Bailey Circus. For twenty years, they performed across the country, not as midgets, but in a routine where they danced, sang and appeared in tableaus in which they struck poses in elegant attire.

They retired to their State Road home, opened a teahouse at the Sign of the Spinning Wheel, sang and played for guests and served chilled ices and chocolate. They taught Sunday school locally and throughout New England. Letters of praise flowed in. Sarah died in 1938; Lucy lived on in a modified campground cottage and passed away in 1954. Neither sister married, and there were no progeny. No one knows why the women never grew to normal height.

Nancy Luce (1814–1890) does not fit neatly into any ordinary category in the history of Martha's Vineyard. She was a nineteenth-century anomaly, a woman who lived a lonely life up-island. "She was a folk artist, poet,

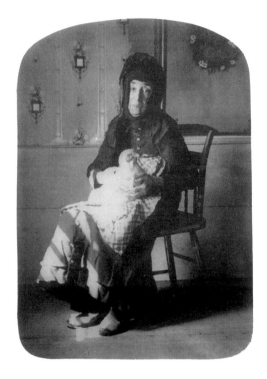

businesswoman and writer, and some say the first female entrepreneur on the Island."[46]

In the archives of the *Gazette* we learn that, in her youth, Nancy Luce was a prominent horsewoman, galloping across farm and field. The story goes that she was betrothed, and her fiancé died at sea; this calamity caused her to withdraw from her community. She cared for her ailing, aging parents. When they passed away, she spent the last forty-five years of her life in her own home, subsisting off the land, with chickens her closest companions.

In her eccentric lifestyle, she forged a career as a businessperson, a poet and a spinster who benefitted from her creative ventures with tourists and locals. Nancy Luce wrote poetry, composed in neatly scripted pages and printed and bound in thin pamphlets, which

This page: Nancy Luce was known as the "Chicken Lady." She earned a small income when she allowed herself to be photographed. She sold eggs, tobacco and hand-knit socks. Today, admirers from across the country flock to her grave, festooned with chickens in her memory. *Courtesy of Martha's Vineyard Museum; photo by Thomas Dresser.*

she sold from her New Lane retreat in West Tisbury. She berated visitors who failed to respect her strict Christian doctrine; on occasion, she brandished a pistol against the wayward behavior of those who sought her out for ridicule.

Colloquially known as the "Chicken Lady," she has become larger than life since her death. In her eccentricity, she had tombstones carved for her dear chickens: Teedla Toona and Levendy Ludandy, Ada Queetie and Beauty Linna. And her own gravestone stands at the West Tisbury cemetery on State Road, festooned with statues of chickens. Nancy Luce would have approved.

OF FAIRS AND REVIVALS

A highlight of the Vineyard for over a century and a half is the annual Agricultural Fair, which celebrates the harvest, in mid- to late August. Local farmers share their wares and their animals and are judged from the biggest turnip to the strongest ox. Music, crafts, food and sociability are hallmarks of the fair. Traditions abound and now include tractor pulls and women's skillet tosses, in addition to the vegetable and animal judging.

Amid the rural nineteenth-century economy, the *Vineyard Gazette* began publication as a weekly newspaper in 1846. The broadsheet still publishes today, making it the oldest newspaper on the Vineyard. The first publisher, Edgar Marchant, designed his *Gazette* as "a family newspaper devoted to general news, literature, morality, agriculture and amusements," amid advertisements for patent medicines that promised amazing cures. By the turn of the century, it faced competition but maintained its restrained, efficient style.[47]

George Hough, father of Henry Beetle Hough, purchased the *Gazette* in 1920 from Charles Marchant, great-nephew of the founder, as a wedding present for Henry and his new wife, Betty. The Houghs set the tone of the paper for the next century: dignified, serious accounts and opinions of the news of the week. The Houghs raised public consciousness to preserve the rural ambiance of the Vineyard.

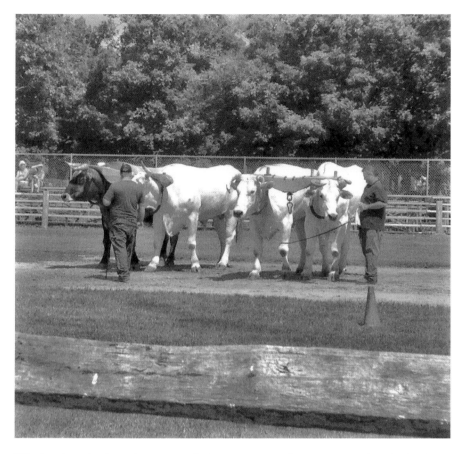

Whether the animals are large or small, they attract attention at the annual Agricultural Fair. The first fair was held at the Grange Hall in 1858; the fair relocated to the new Agricultural Hall in West Tisbury in 1995. *Photo by Joyce Dresser.*

In the mid-1850s, a key landmark rose anew on the Gay Head Cliffs. While the original structure was wooden, the new lighthouse was built of local brick from the Smith and Barrows Brickworks on Roaring Brook, Chilmark. A Fresnel lens was added, visible twenty miles out to sea, warning the expanding shipping trade of the danger off the Gay Head Cliffs.

The Civil War erupted. Volunteers enlisted from the three island towns: Edgartown (which included Oak Bluffs), Tisbury (which included West Tisbury) and Chilmark (which included Gay Head). Young men were caught up in fierce battles. Alfred Rose, a Gay Head Wampanoag, was the youngest

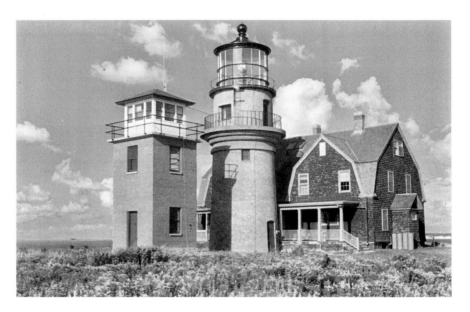

The Gay Head lighthouse, authorized by President John Adams in 1799, was rebuilt in the 1850s with a keeper's cottage attached, as indicated by this old Gay Head postcard. The square brick structure functioned as a lookout station during the Second World War.

man killed in the Battle of Petersburg. He was fifteen. (The historical novel *Seen the Glory*, by John Hough, recounts another young Vineyarder's experience at Gettysburg.)

Two African Americans from Martha's Vineyard served in the Fifth Cavalry. James Curtis and James Diamond were each forty-one when they enlisted in 1863 and were assigned to protect Washington, D.C. Their unit was a cavalry force, but it was reassigned to infantry without proper training. Pay was ten dollars a month, of which three dollars went for uniforms. (White soldiers were paid thirteen dollars a month and received an additional three-dollar clothing allowance.)

The obelisk at Memorial (Cannonball) Park in Edgartown is a tribute to seventy Vineyarders who participated in the Civil War. It was erected in 1901.

Amid the lingering shadows and shards of the Civil War, local veterans gathered to toot their horns once again. The Vineyard Haven Band came into existence in 1868 and today performs as the oldest continuous musical ensemble on the island. Over the years, the band has marched in patriotic parades and performed weekly concerts, as well as playing for the Grand Illumination and annual fireworks display. For decades, neither women nor woodwinds were welcome, but such restrictions have been lifted.

People are curious about the campground, the Martha's Vineyard Camp Meeting Association of Wesleyan Grove in Oak Bluffs. Is it unique?

It was a Methodist summer retreat. Similar sites were established in Ocean Park, Maine; Orange Grove, New Jersey; Round Lake, New York; Balls Creek Campground, North Carolina; and Toronto, Ohio, as well as Ontario, Canada. What makes Wesleyan Grove special is that it is still a viable community today. It was declared a National Historic Landmark in 2005.

The Camp Meeting Association began in 1835, when Jeremiah Pease, Thomas Coffin and Frederick Baylies paid fifteen dollars for acreage beneath shady oaks on the shores of Sunset Lake in Oak Bluffs. They established a revival meeting with nine tents. "From the work of these three men grew the largest Methodist camp-meeting associate in the world, and from that one of the best known watering places on our coast."[48] Wesleyan Grove was named for John Wesley, the founder of Methodism. He advocated outdoor evangelism.

Within four years, the revival meeting increased to 17 tents, and by 1853, it had expanded to 160 tents. Tent sites were laid out in concentric circles on the association grounds. Methodists flocked to this summer resort and listened to preachers fervently expound on the word of the Lord.

Over the first two decades, revival meetings focused exclusively on religious functions, but by the mid-1850s, participants took advantage of the fresh air and saltwater bathing beaches of Oak Bluffs. Each year, camp meetings grew, eclipsing two hundred tents by 1859. That year, the first permanent structure, the Camp Meeting Association building, was built. Also, the first two wooden cottages were built.

The grounds overflowed with five hundred tents and fifteen thousand participants. It was such a big deal that in 1862, Massachusetts governor John Albion Andrew came to the Camp Meeting Association to give an impassioned antislavery speech to garner support for the Civil War. He encouraged support for the Fifty-fourth Volunteer Infantry Regiment, made up of African Americans and led by a white man, Colonel Robert Shaw. (See the movie *Glory*.)

Cottages were erected on the tent platforms. Virtually all five hundred cottages were built between 1862 and 1880. Check the dates over the doors. By 1880, the thirty-four acres of Wesleyan Grove was a hive of summer activity.

The cottages are similar in size and style, with two rooms on the first floor and two bedrooms above. Double doors on the second floor opened to allow

This campground cottage is typical of the hundreds of cottages at the Camp Meeting Association. Neither a kitchen nor a bathroom was in the original construction; nor was there a basement. The filigree, or wooden trim, was added later, creating the gingerbread cottage allure. *Photo by Joyce Dresser.*

furniture to be hoisted upstairs, as the stairs are quite narrow. Bright-colored paint came later, too. This style is known as American Carpenter Gothic.

Over the years, the Camp Meeting Association has continued to attract supplicants, tourists and residents. Cottage owners rent land from the association; regulations on race and religion, initially instituted, have since been repealed. "Peddlers were not allowed on the camp-ground, but one man from 'up-Island' took a chance and brought down a load of farm produce and drove among the tents, singing good old Methodist revival hymns. He sold that cart load, and many others."[49]

Methodist campground congregants were warned not to frequent Cottage City because it was considered a haven for depravity, with dance halls and bars. The town thus gained a reputation for two distinct lifestyles, so separate that a seven-foot-high fence was erected in 1867 to separate the two entities. The fence gate was locked at 10:00 p.m.

Across the fence, Circuit Avenue flourished as a community of party people, as it does today. Within the gated community, staid Methodists

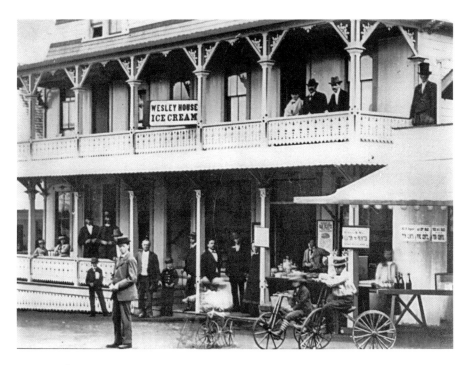

Wesleyan Grove developed as a self-sufficient community with a commercial district by the Wesley Hotel, which included a bakery, an ice cream parlor and small shops. Other businesses were centered near the Arcade, by Circuit Avenue, a busy part of town. *From the collection of Connie Sanborn.*

prayed and preached. These two cultures, so close, abutted each other, as well as butted heads.

Wesleyan Grove Campground was incorporated in 1868 and boasted some thirty thousand participants and visitors. Revival meetings were conducted beneath a great canvas tent, as oak trees no longer provided sufficient shade.

As the summer of 1869 drew to a close, an end-of-season celebration included a display of candle-lit Japanese paper lanterns. The festivity was characterized by "glowing oriental lanterns, fireworks, parades and music provided by the Foxboro Brass Band."[50] Today, the Grand Illumination draws thousands.

The *Monohansett* was a side-wheeler ferry serving Martha's Vineyard when it was appropriated by the government during the Civil War, "carrying troops to Newborn and Hilton Head, North and South Carolina." It later saw service on the James River. During that time, it was used as General Grant's dispatch boat, operating off Cape Hatteras and around the Potomac. A mahogany table from the saloon is in the Martha's Vineyard Museum and "bears a stain that looks very much as though it might have come from one of Grant's whiskey bottles."[51]

After the war, the *Monohansett* returned to plying the waters between the Vineyard, Woods Hole and New Bedford. The *Monohansett* "was credited with bringing a record crowd to the Vineyard for the Camp Ground meeting, carrying 1,400 over in the morning and 1,800 passengers back in the evening."[52] Another Vineyard steamboat, the *River Queen*, also served as a dispatch boat for General Grant. A key meeting between Abraham Lincoln and Alexander Stephens, vice president of the Confederacy, took place on the *River Queen*.

President Ulysses S. Grant visited Martha's Vineyard in 1874. He arrived aboard the *River Queen* and docked at the Highland Wharf. He was then transported in "one of the Vineyard Grove cars, drawn by six horses and appropriately decorated for the occasion, and, followed by a numerous concourse of carriages and pedestrians, proceeded to Clinton Avenue."[53]

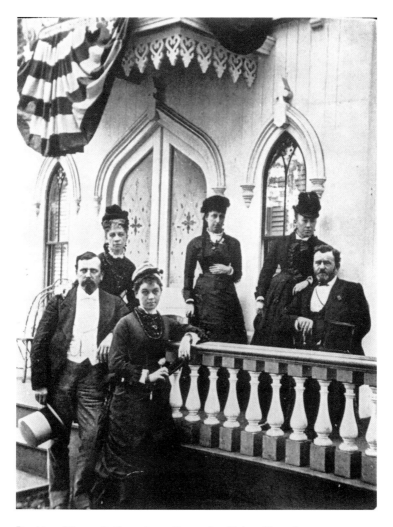

President Ulysses S. Grant (seated) stayed at Bishop Haven's cottage on Clinton Avenue in the campground, as a sign on the balcony attests. He was welcomed by the Vineyard Haven Band and made an appearance at the gazebo on Ocean Park. *From the collection of Connie Sanborn.*

"A gala celebration was held at Cottage City with fire works, a marching band and a parade of carriages. The town was decorated with banners and bouquets of flowers including a wreath with the word 'Peace,' that was centered in Ocean Park."[54]

President Grant inaugurated service for the Active, a steam locomotive that ran from Oak Bluffs to Edgartown. He visited the house of Dr. Harrison Tucker,

a magnate in patent medicine, in which cocaine was a prime ingredient. Tucker's house, with its raised red roof, is at the corner of Ocean Park.

President Grant was on the Vineyard for three days. "Amid a perfect burst of applause, the President was presented [at the Campground], bowing in response to the enthusiastic salutations of the multitude."[55] He savored Grand Illumination night and dined at the Sea View Hotel.

The *New York Herald* reported, "The rustic policemen who were on duty found their authority was not respected and early in the evening they surrendered to the multitude; probably not less than a thousand ladies and gentlemen were presented to the President." After morning service, Grant boarded the *Monohansett* for New Bedford.

Grant's visit proved popular. "It was, some say, a turning point for island culture. After Grant, the tourists came. Virtually unheard of before the 1850s, 'summer people' were an island institution by the end of the century."[56]

As summer camp meetings continued to expand, an imposing wrought-iron Tabernacle was erected in 1879 to replace the canvas tent. It seats 3,500.

The Tabernacle continues to serve the community well, hosting religious services, concerts, public events and the annual high school graduation. *Photo by Joyce Dresser.*

Today, Wesleyan Grove is made up of 315 cottages, about 40 of which are lived in year round. Many more are insulated and heated and used in the off-season. Camp Meeting Association cottages were initially available only to Methodists, but that tenet was relaxed during the Depression years. Noisy activities in the campground, such as the use of power tools, are prohibited in July and August; quiet time is from 11:00 p.m. to 8:00 a.m. The cottages may be rented only six weeks per season.

Community sings have been a part of the summer campground experience since the 1920s. On Wednesday evenings, all summer long, enthusiastic singers join in song beneath the impressive Tabernacle at the heart of Wesleyan Grove.

Not far from Wesleyan Grove is all that remains of the Baptist campground in the Highlands off New York Avenue. A great tabernacle also served as a hub for many houses; unfortunately, it burned in 1944. An overgrown field with cement footings reminds visitors of this Baptist religious community.

Baptists and Methodists shared the religious revival fervor that enthralled the late nineteenth century. The two communities were linked by a bridge, later a roadway, along what is now the bulkhead of Oak Bluffs Harbor, known colloquially as "crossing the river Jordan."

Chapter 8

THE INDUSTRIAL REVOLUTION

Shortly after the Civil War, community leaders sought to fully assimilate the Wampanoag into the white man's culture. It became embarrassingly evident that all men were not being treated equally on Martha's Vineyard. When the Thirteenth, Fourteenth and Fifteenth Amendments were passed by Congress and ratified by two-thirds of the states, African Americans were freed from bondage, made citizens and (males) allowed to vote.

Not so with the Wampanoag. They were not allowed to vote, as they were not individual property owners; rather, they owned land in common. To right this wrong, the Wampanoag were persuaded to give up their communal land in return for the right to vote (enfranchisement). That land was promptly sold to the wealthy (white) population, which consequently pushed the Wampanoag another step down the economic ladder. This began during the Civil War and continued until April 15, 1870, when Gay Head became a separate town from Chilmark. It took more than a century to rectify this land grab for the Wampanoag.

This 1870 partition, or land redistribution, left Native Americans to fend for themselves. They managed. Through tenuous records of local officeholders and treasured documents of tribal meetings, the Wampanoag achieved federal recognition and regained their land in 1987.

Life in Gay Head persisted, but it was life apart from the rest of the Vineyard. Roads were nearly impassable. Oxen were the primary means of transport. But oxen are slow. One could ride a horse to Vineyard Haven,

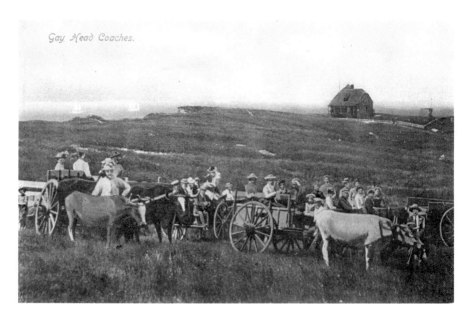

This page: A pier was built in Gay Head in 1883 near the lighthouse. Tourists traveled by steamship to see the land of the Wampanoag, exclaim at the clay cliffs and stand by the lighthouse. Small hotels and restaurants opened in the summer. Native Americans sold handcrafted goods: pottery, beads and carvings. Ox carts provided transportation around the cliffs. *From the collection of Connie Sanborn.*

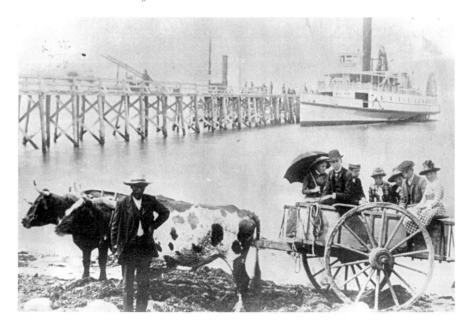

some twenty miles to the north. Horses were rested or exchanged in West Tisbury; the Howes House on State Road served such a purpose.

For Native Americans in Gay Head, it was easier to sail to New Bedford to shop than to drive a horse and buggy down-island. It was a straight shot across Buzzard's Bay. Thus, the people of Gay Head lived isolated lives and made do.

Tourists and locals from down-island visited Gay Head by land, but it was an arduous journey. A more efficient transport was by steamer, as attested by advertisements in the *Vineyard Gazette* of the 1880s and 1890s. Steamers to Gay Head included a brass band. Photos show a steamship docked at the pier in Gay Head, with oxcarts to transport guests to a hotel. A glance at the register of Nestle Nook, a local guesthouse, indicates the many visitors who appreciated the hospitality afforded them.

Town politics flourished in the decades following the Civil War as Martha's Vineyard decided to divide and devise new ways to define itself. The southwest corner of Chilmark became the town of Gay Head.

West Tisbury broke away from Tisbury in 1892. This prominent building was initially the Dukes County Academy and then the West Tisbury School before becoming the town hall. *From the collection of Connie Sanborn.*

A decade later, in 1880, townspeople voted to secede from Edgartown and form their own town, Cottage City. The name was changed in 1907 to Oak Bluffs.[57] And West Tisbury separated from Tisbury in 1892.

The industrial revolution made its way, ever so gradually, to Martha's Vineyard. The woolen industry that had been decimated by the British in 1778 gradually had improved by the Civil War. Evidence lies by the Mill Pond in West Tisbury. That building served as a woolen mill, churning out satinet, a product popular with whale men and sailors for its durable, water-resistant quality.

In 1859, that mill was sold to whaling captain Henry Cleaveland. However, business at the mill slowed as "whaling, due largely to depredations by the Confederate raiders, *Alabama* and *Shenandoah*, was in a lull."[58] The mill was no longer financially viable. Business dried up in the 1870s. Since 1943, the old mill building has been home to the Martha's Vineyard Garden Club.[59]

Another Vineyard industry that flourished in the mid-nineteenth century was brick making. Clay was mined, formed and heated to make bricks.

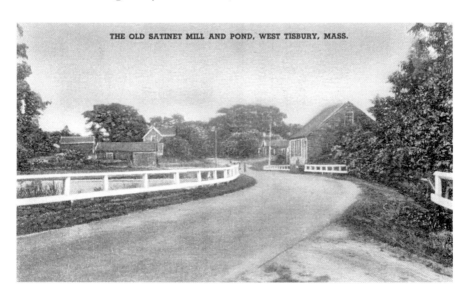

THE OLD SATINET MILL AND POND, WEST TISBURY, MASS.

This page and next: The *Vineyard Gazette* reported in 1846, "Since the putting up of the Bradley Woolen Mill, in West Tisbury, there is, we are told, a decided improvement in real estate in that pretty village. This little place, decidedly the most cultivated and picturesque in the country, has felt revivifying influence." *Postcard; photo by Joyce Dresser.*

There were two brickyards: a small one off Makoniky in West Tisbury and a more prominent establishment in Chilmark.

Smith and Barrows began mining clay along Roaring Brook in Chilmark in 1849: "In 1854, Smith and Barrows brick works had a deep water dock. Schooners would secure themselves to the docks with lines to the dock and load up with bricks, clay, paint, iron ore and perhaps milled grain from the nearby gristmill."[60] Bricks were shipped in large sailing coasters to Providence, Fall River and Boston.

By 1869, a massive brick factory had been erected near the Chilmark shore. The business changed hands, and it was known as the Chilmark Brick and Tile Works. It proved successful, churning out sixty bricks a minute—600,000 to 800,000 bricks per year. Up to seventy seasonal employees were hired to work the brickyard.

Three large brick barns were built nearby, in the 1850s, from discarded or damaged brick. Osborn Tilton's barn on North Road was blown down by the 1938 hurricane. John Hammett's barn was known for its arched wagon doorways. James North Tilton's barn, off Middle Road, was converted to a brick farmhouse.

In the late nineteenth century, Tilton's barn, by Meetinghouse Road, was then in the center of Chilmark. Two Methodist churches, Flanders general store, a parsonage and a post office were located near Tea Lane and Middle

Road. By the 1890s, however, a new town hall was built three miles south, at Beetlebung Corner, and the Methodist church soon followed as the town center shifted southward.

In the early 1800s, another little community flourished in Lambert's Cove. This village offered

> three stores, two school houses and many farms. It boasted of three wharves before Vineyard Haven had any, and many ships anchored in the Cove. There were salt works on the shore and smoking houses on the hill where the fat herring were cured and made ready for market. A large lumber yard was situated near one of the wharves.[61]

A cranberry bog and fish weirs were nearby.

Manifestations of local brick survive: The Gay Head lighthouse required tons of brick hauled over rugged terrain in ox carts. Waterworks buildings in Oak Bluffs were brick, as was the Dukes County Courthouse and the old Carnegie library on North Water Street in Edgartown.

Making bricks required heat, generated by burning wood. Once local trees were burned, the brick business fell off. It was not financially feasible to haul wood to the Vineyard to make bricks and then ship bricks off-island. The brick business closed down in 1899. (In 2014, the Trustees of Reservation was gifted the brickworks property, now in disrepair. Access to the grounds will be from Menemsha Hills or Great Rock Bight.)

Another business was paint: "In 1850 the Nye Brothers of Falmouth started a paint mill. The paint was made by grinding the colors from the clay on the shore. At the height of the industry about fifty thousand pounds were made yearly."[62] A gristmill along the Roaring Brook brickyard served as a paint mill in the mid-1800s. The Carpet Mill paint factory was also along this brook. Paint was used to dye carpets.[63]

Another product from natural resources was ice.

Harvesting ice from local ponds began outside Boston in 1806, when Frederic Tudor cut ice, packed it in sawdust and hay and created a whole new dining phenomenon.[64] Now, cool drinks could be served in summer. Perishable food could be served far from home. Food stayed fresh. Fruits, vegetables, meat and dairy products could be preserved.

Icehouses proliferated. Ice House Pond and Mill Pond in West Tisbury, Crystal Lake in Oak Bluffs, Ice Pond in Chilmark and Sheriff's Meadow in Edgartown proved popular for harvesting ice. Men and horses cut, dragged and stored ice in icehouses. This business flourished from the late nineteenth century to the mid-twentieth century.

Crystal Lake generated ice from 1906 to 1944, with two icehouses. Fifty men were paid thirty-five cents an hour to harvest ice. They separated ten-inch blocks with long poles and then floated the blocks into a canal of open water. Blocks were guided to a horse-powered treadmill, and the ice was moved into the icehouse, packed with eighteen inches of sawdust. Two thousand tons of ice was harvested in four days. The price of ice was one dollar for one hundred pounds.[65]

The Hurricane of 1944 decimated both icehouses and left salt in the lake, which contaminated the ice. Crystal Lake was sold to the East Chop Association in 1962.

Cutting ice from Crystal Lake in East Chop. According to the *Boston Globe* of December 21, 2014, "The ice trade was a catalyst for a transformation in daily life so powerful that the mark it left can still be seen on our cultural habits even today." *Courtesy of Joyce Dresser.*

The ice of the Mill Pond was harvested in the days before indoor refrigeration:

They had a machine that marked it in squares, [recalled Dionis Coffin Riggs]. *A horse would drag the machine, so the ice had to be pretty thick. Then they'd take big saws and saw down these marks and then they'd make one row somehow. And push these out onto a ramp in a truck wagon. Then it would be taken to the icehouse and stored with hay. The icehouse was in back of that house next to the police station on the Mill Pond. That is where you got your ice all summer, from there.*[66]

Seven Gates is a sprawling landscape off North Road in West Tisbury. Originally made up of small farms, the properties were bought by Professor Nathaniel Shaler of Harvard in 1888. A geologist, he was intrigued by the formation of the Vineyard. (He was the proponent of laying a base of cheesecloth on the sandy road along State Beach to secure it for pouring concrete; hence, "the cheesecloth highway.") After his death in 1906, the land became a dairy farm with sixty cows. Butter was shipped south. The farm closed in 1921, and an association of the old farmhouses was formed.

Seven Gates is off the beaten path. In the months preceding World War II, noted aviator Charles Lindbergh ensconced himself at Seven Gates to avoid publicity for his pronounced isolationist views. His wife, Ann Morrow, found solace in writing poetry in the nearby woods. (After Pearl Harbor, Lindbergh embraced the war effort and flew combat missions in the Pacific.)

Today, thirty-five homes are scattered across some 1,650 acres. Residents of Seven Gates celebrate Daffodil Day when they tour neighbors' grounds to admire the bright yellow flowers nestled in the woodlands and fields of this expansive, exclusive community.

Immigrants from the Azores and Cape Verde settled down-island, initially in Oak Bluffs: "Two brothers, Antone and Domingo Medeiros, emigrated from the Azores to New Bedford, then settled on the Vineyard in the 1880s. Later, Antone moved up-island to West Tisbury and became a farmer. Domingo Pachico Medeiros (Alley) remained in Oak Bluffs."[67]

Family lore has it that the surname "Alley," a play on halibut, was derived from a nickname given to Antone when, as a teenager in Cottage City (Oak Bluffs), he peddled fish in the Portuguese community. Whatever its origins, the name was thought to be far easier to deal with than "Medeiros," and it was adopted by nearly all of the family members.[68]

Betty Alley was born in Oak Bluffs in 1912, in an area known as Little Portugal. "Both her parents were born in the Azores, on the island of St. George, and immigrated to Martha's Vineyard in their youth."[69] More people moved to the Vineyard as first-generation immigrants enjoyed success on another island in the Atlantic. (This was actually a second wave, as whaling sailors from the Azores arrived earlier.)

"Those who enjoyed Cape Verdean music had a site to appreciate it."[70] The Portuguese culture arrived. Joseph Stiles recalled a musical experience: "The dances they used to have at the Cape Verdean Hall when I was stationed on the island during the war. We never missed one of them. All the sailors used to go." He recalled that the band played "all Cape Verdean music. Their dances are like a reel. You don't get in the middle of the floor and just drag around. You'd be dancing like mad, but you'd be going in a circle so nobody would be bumping into each other."[71]

So the people of Portuguese descent were integrated with the Native Americans, African Americans and descendants of white settlers. By the turn of the century, Martha's Vineyard reflected the United States as a melting pot of nationalities, living and working together, yet each clustered in its own community.

———

Vineyard Haven suffered a devastating fire on August 11, 1883. It began in a harness factory on Main Street, the present site of the Santander Bank. "Sweeping southward it burned every building on both sides of Main Street as far as the old Luce house just above the fountain."[72] More than sixty buildings were destroyed. "You would not know that wood could be reduced to such little piles of ashes, that great timbers could be utterly consumed, that burned house furnishings could leave no trace of their passing unless you had seen Vineyard Haven on its morning after."[73] The fire burned over forty acres.

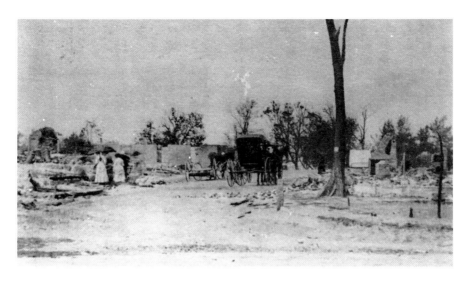

The Vineyard Haven Fire of 1883 was devastating. The *Vineyard Gazette* described the destruction: "So utterly had the familiar landmarks of Main street disappeared that some old timers found it difficult to get their bearings when they ventured forth." *From the collection of Connie Sanborn.*

Henry Beetle Hough reported on the fire, thirty-seven years afterward:

The glow from the fire could be seen for miles, and was plainly visible from New Bedford. The night was thick and there was a little drizzle, which, however, did not aid in putting out the flames. And the wind roared up the street in that terrifying way that only the fire king can dictate. He made his last desperate stand at the Mansion house, leaping across the street to burn two or three houses on the other side, then veering off to the west, where he was finally conquered.

LAND MANAGEMENT, PART 1

Land development was all the rage in the late nineteenth century in the down-island communities of Vineyard Haven, Oak Bluffs and Edgartown.

A plan for Vineyard Haven was conceived in 1872 to compete with Wesleyan Grove. Between the Edgartown–Vineyard Haven Road and the Lagoon, a map envisioned 664 house lots. The hub of the development was a plush hotel with a five-story tower built on the shoreline in 1876. It was named Oklahoma.

Cottages were to be in the Stick style of Gothic architecture rather than the quaint gingerbread design in Oak Bluffs. Only six cottages were built. House lots failed to attract buyers because it was too difficult to access the site. The development was never completed.

The hotel, however, thrived. In the mid-1890s, it was sold to two intrepid entrepreneurs, Tom Karl and Dellon Dewey Jr. They staged theatrical productions and offered Innisfail, as the hotel was renamed, as a haven for singers, actors and artists. It proved popular until it was consumed by fire in 1906, along with half the cottages. It was never rebuilt. The three surviving cottages are on Bellevue Avenue, off Oklahoma.

Another land development was in Katama, in south Edgartown. It, too, faced the challenge of limited access. The Katama Land and Wharf Company began operations in 1872, attracting the tourist trade to the south shore. That year, the Old Colony Railroad reached Woods Hole, and Beach Road, from Oak Bluffs to Edgartown, opened along State Beach.

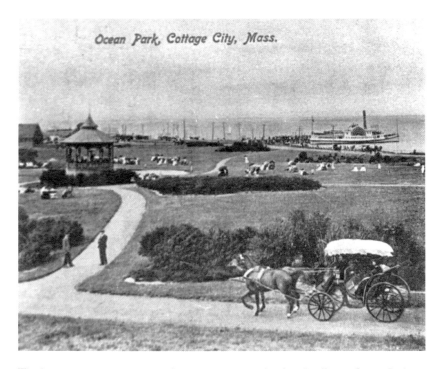

The largest greensward Robert Copeland designed for Oak Bluffs was Ocean Park, a seven-acre centerpiece, capped by the quintessential bandstand. This postcard is labeled Cottage City, so it is prior to 1907. Note the side-wheeler at the pier. *From the collection of Connie Sanborn.*

The bandstand in Ocean Park was erected in the 1870s and has served as the stage for the Vineyard Haven Band for more than a century. *Photo by Joyce Dresser.*

The developer sought to attract customers to his new Mattakeesett Lodge. Within two years, he got what he wanted with the railroad.

And in the latter part of the nineteenth century, Oak Bluffs underwent major land development projects. The Oak Bluffs Development Commission laid plots to be sold for houses. Landscape architect Robert Morris Copeland designed parklands within the development. (Copeland had worked with preeminent landscape architect Frederick Law Olmsted, who designed Central Park in New York City and the Emerald Necklace in Boston.) Robert Copeland designed swaths of green that invigorate Oak Bluffs.

Also in Oak Bluffs, in 1868, the Vineyard Grove Company sought to isolate the Methodist Camp Ground from the laissez-faire community of the Oak Bluffs Land and Wharf Company. (This was the genesis of the seven-foot fence, built in 1867.) The Vineyard Grove Company purchased property in the Highlands in case the Methodists needed to move farther out of town. It built the Highland Wharf to accommodate ferries for the Methodist revivalists.

Vineyard Grove Company constructed a 3,500-foot wooden boardwalk from the Highland Wharf, the present site of the East Chop Beach Club, down to the Inkwell. This boardwalk inspired "bluffing," or walking along the shore past Lover's Rock, off Ocean Park. (This was before Lake Anthony was opened to the sea, creating Oak Bluffs Harbor.)

Above and opposite, top: The Ocean View and Wesley House were two prominent hotels that catered to the crowds who flocked to Oak Bluffs. The Highland House, Prospect House and Sea View also were popular in the late nineteenth century. *From the collection of Connie Sanborn.*

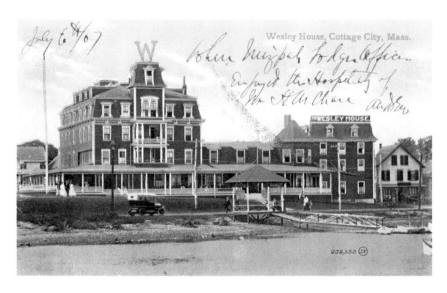

The statue of a Union soldier was initially installed by the Flying Horses, at the head of Circuit Avenue, where there was, later, a traffic light. The statue was relocated to a corner near Ocean Park in 1930. *From the collection of Connie Sanborn.*

The Highland House Hotel was built next to the Highland Wharf in 1871 by the Vineyard Grove Company. It boasted 150 rooms and stood four stories high—an impressive seaside sight.

Nearby was the Summer Institute, a school to train teachers, which flourished from 1878 to 1907. At its height, forty teachers serviced more than seven hundred students.

Competing with the Highland House was the Sea View Hotel. The Oak Bluffs Land and Wharf Company built it in 1872. The Sea View was near the Oak Bluffs town pier, the other ferry slip. A skating rink and toboggan slide attracted visitors. Efforts were in vain, however, as the company went bankrupt in 1885, and the properties were auctioned off.

In downtown Oak Bluffs, a statue of a Union soldier was given to the town in 1891 by Charles Strahan, editor of the *Martha's Vineyard Herald*. Fashioned of zinc, it was painted gray in 1980, restored and rededicated in 2001. Strahan was a Confederate war veteran and donated the statue to heal lingering angst over the Civil War.

To attract tourists and visitors to these newly developed properties, Vineyarders turned to new means of transportation.

Horse-drawn streetcars began operation in 1873.

The burgeoning number of Methodist revivalists to Wesleyan Grove necessitated a horse-drawn trolley, put into service in the 1870s. (A piece of

Horse-drawn streetcar service began in 1873 to transport passengers and luggage from the Highland Wharf to Trinity Park in the campground. The cost of the ride was six cents. *From the collection of Connie Sanborn.*

The mail wagon was a familiar sight, traveling between Oak Bluffs and Edgartown. *From the collection of Connie Sanborn.*

the track is preserved by the Camp Meeting Association building.) In various forms, such transport continued until 1917, for some forty-five years.

Oak Bluffs obtained electric power, so the horse-drawn trolley line was electrified in 1895; several cars were converted to electric use. The Cottage City Street Railway Company built a line to the Prospect House Hotel (off Alpine Avenue) and beachfront facilities on the Lagoon (off Barnes Road). This line closed after a fire destroyed the Prospect House in 1898.

Another spur led to the New York Yacht Club pier in Eastville on East Chop Drive. Both horsecar and electric trolleys serviced this site when the Yacht Club visited the Vineyard. In 1895, some 135 sailing vessels made up the flotilla of New York yachters, who leant their name to the prominent avenue leading to the pier.

Trolley cars were reversible. Instead of turning around, the conductor reversed the trolley pole from the overhead wire, and the motorman, who ran the car, walked to the other end of the car to operate it. The versatility of the electric railway car was exemplified when a ball of yarn rolled off the side of the car. The passenger notified the conductor, who notified the motorman, who stopped the car. They reversed direction, picked up the ball of yarn, reversed direction again and proceeded on their way.

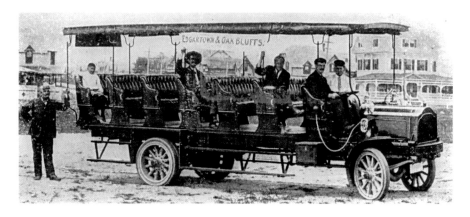

In 1906, the trolley lines from Oak Bluffs and Vineyard Haven merged, creating the Oak Bluffs Street Railway, which continued until 1917. This multi-passenger omnibus contributed to the demise of the trolley line, as it offered more versatile services. *From the collection of Connie Sanborn.*

In Vineyard Haven, the Martha's Vineyard Street Railway Company laid a mile of track from the present Steamship wharf through Five Corners out to the drawbridge, using fifty poles to support the wires. The drawbridge was too weak to sustain the railway cars, so passengers disembarked, crossed the bridge and boarded the competing line. If the other streetcar had not yet arrived, the Eagleston Tea House, by the bridge, sufficed in the interim. (The Tea House was destroyed in the 1944 hurricane, replaced by a private home, which, in turn, was demolished in 2014 for the latest incarnation of a drawbridge over the entrance to the Lagoon.)

The Martha's Vineyard Railroad experienced an inauspicious beginning in 1874, when the locomotive Active was knocked off a flat car and into Woods Hole Harbor. It was hauled out, wiped down and cleaned up, and it made its way safely to Martha's Vineyard to begin operations between Oak Bluffs and Edgartown on August 22, 1874.

The locomotive was originally named the Active and later renamed the Edgartown. The railroad consisted of a tender and four cars: two enclosed coaches, an open car (the Katama) and a baggage car, which accommodated passengers. When the train pulled into its wye, or triangular junction, the

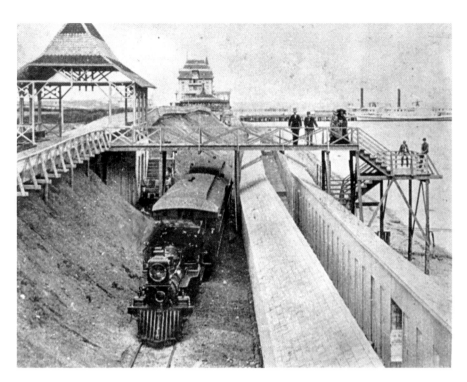

This page: From 1874 to 1895, this steam-powered locomotive brought tourists and locals from Oak Bluffs along the shoreline to the Depot Corner station in Edgartown. *From the collection of Connie Sanborn.*

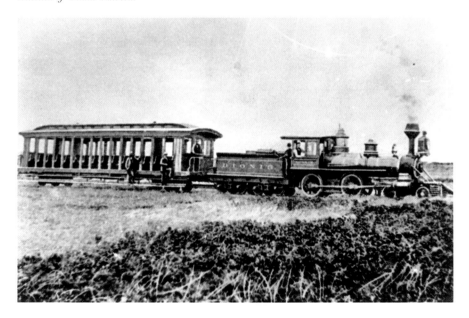

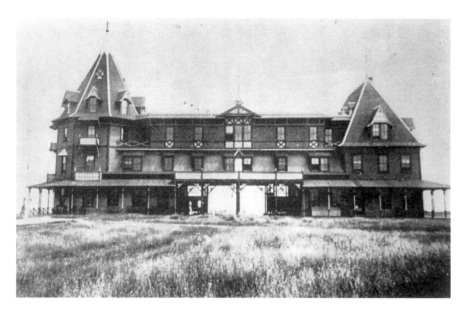

The train continued out to the Mattakeesett Lodge in Katama and South Beach. Prior to the automobile, the train proved more efficient than a horse and buggy. *From the collection of Connie Sanborn.*

conductor switched the seatbacks so passengers would face in the direction they were heading, just like the trolley.

For twenty years, from 1874 to 1895, this steam-powered locomotive brought tourists and locals from the terminal in Oak Bluffs along the shoreline by Pay Beach, past the Inkwell and along State Beach, turning up across what became the Edgartown Golf Course, by the jail, halting at Depot Corner station in Edgartown and then on to Katama. This allowed tourists to appreciate the soft sea breezes of the South Shore. (And it made money for the Mattakeesett, built by Erastus Carpenter, the entrepreneur behind the Grand Illumination and the railroad and a proponent of the secession of Cottage City from Edgartown.)

The trip from Oak Bluffs to Edgartown took twenty-five minutes. One busy day, there were 412 passengers from Oak Bluffs to Katama and back. A passenger could ride both ways and enjoy a clambake or a dance in Katama for one dollar. The train ran from mid-June to mid-September, with high season from July 4 to Labor Day. To coordinate schedules, the train met the steamship in Oak Bluffs.

On September 24, 1892, a suspicious fire at the Sea View Hotel in Oak Bluffs consumed not only the hotel but also the wye, so the train could no

Edgartown was the provincial county seat for Dukes County, complete with a Main Street with businesses, the county courthouse and a jail. Horses and buggies ruled the roads. *From the collection of Connie Sanborn.*

longer turn around. For the last three years of its existence, the Active/ Edgartown locomotive pulled the cars to Oak Bluffs and then pushed them back to Edgartown.

(The Sea View was not the only Oak Bluffs hotel to suffer from arson. A.J. Wesley, proprietor of the Wesley House, was apprehended as he attempted [unsuccessfully] to torch his hotel. He served time for his misdeed.)

Blowing sand deluged the tracks along State Beach. The financial return on the railroad did not meet expenses. Ridership fell off after the Mattakeesett closed. By century's end, train service had been discontinued. Relics of the railroad are visible with posts sticking up by Farm Pond, and a house in Oak Bluffs was built around one of the old cars.

In Reverend Herman Page's *Rails Across Martha's Vineyard*, one encounters descriptions of the Martha's Vineyard Railroad, with "marvelous detail in words and images about how the coaches of the railroad were designed, built and operated, where the rails ran and where, surprisingly, traces of the system may yet be found."[74]

MENEMSHA-BY-THE-SEA, MARTHA'S VINEYARD ISLAND, MASS. 1223

This page: Menemsha Harbor was made more accessible for fishing boats by dredging out the creek. Today, Menemsha is a haven for both fishing and pleasure boats. And it is a most picturesque fishing and tourist community. *From the collection of Connie Sanborn; photo by Joyce Dresser.*

While the Martha's Vineyard Railroad succeeded before the advent of the automobile, another form of transportation met with disaster. Twenty-five years before the *Titanic* rammed an iceberg in the North Atlantic, the *City of Columbus* ran aground and sank off Gay Head.

It was a clear, cold, winter's night—January 17, 1884. The captain was in his cabin, the second mate was unaccounted for, the wheelman was inattentive and the lookout was not looking out. The 250-foot-long steamer *City of Columbus*, en route from Boston to Savannah, struck an underwater boulder, Devil's Bridge, off Gay Head. Of the 132 people aboard, 103 drowned, including all 11 children and all 24 women. The Wampanoag of the Humane Society rescued some of the 29 survivors, all men and mostly crew. The steamship *Monohansett* recovered bodies. The sinking of the *City of Columbus* was the worst shipwreck off Martha's Vineyard and one of the worst wrecks along the East Coast in the nineteenth century. (See *Disaster Off Martha's Vineyard*.)

In dredging up the past, we came across precursors to the Panama Canal, which opened in 1914. Three Vineyard harbors were dredged to improve maritime transport. Lake Anthony was opened to the ocean, creating Oak Bluffs Harbor, in 1899. The new owner of the Wesley House focused the front of his hotel on the new harbor rather than on the campground.

The Town of Tisbury opened Lake Tashmoo, allowing fresh water to flow to the ocean and permitting vessels to use the lake.

Menemsha was known as Creekville, complete with its own post office. The creek was dredged in 1903 to improve access for fishing boats. Hurricanes of 1938, 1944 and 1954 caused significant destruction to Menemsha Harbor.[75]

EARLY TWENTIETH CENTURY

Ferry service between the mainland and Martha's Vineyard had improved incrementally by the turn of the century. The steamship *Uncatena* was launched in 1902 and boasted a nonsmoking cabin, with a sign that read, "No Smoking Abaft the Shaft." When it ran aground in New Bedford, lines were attached to a nearby locomotive, and the *Uncatena* "became the only steamer ever pulled off the bar by a railroad engine."[76]

Sailing was an inexpensive means of transport, dependent only on the wind. Joshua Slocum was the first person to circumnavigate the globe alone, which he accomplished aboard the thirty-six-foot *Spray* from 1895 to 1898. His book, *Sailing Alone Around the World*, stands as a testament to his skill and fortitude. After his accomplishment, Slocum bought a farm in West Tisbury, set sail again and was lost at sea.

The first car on Martha's Vineyard was a 1902 Rambler.

A full-sized replica Rambler runabout is owned by George Hartman of West Tisbury and housed at the Agricultural Fairgrounds.

Hartman's Rambler replica was built by Gas Light Motors of Detroit in 1960. Retired American Motors executives stumbled on original plans for the car and had four vehicles built. The body is similar to the original, with upgraded details, such as headlights, made of aluminum instead of brass. The replica was sold through Rambler salesrooms.

The Rambler design is similar to an open carriage. It has a single-cylinder gas engine with a two-speed transmission and a steering bar, not a wheel. I

This page: The first car on the Vineyard is said to have been a 1902 Rambler. "The car I have was in Ohio," says George Hartman, owner of a Rambler replica, "and was used by a girl to drive from her house to the stables. After she grew up, the folks had a house in West Chop. They brought the car here and would go to cocktail parties in it. It was more of a plaything." *From the collection of Connie Sanborn; photo by Thomas Dresser.*

asked George Hartman if his car runs. It does. "It's hard to drive, but can go as fast as thirty miles per hour," he says. "It has a jerky start but runs well. I had it in the 150th anniversary parade of the Agricultural Society [in 2011], and I usually run it at the Harvest Fest in the fall."

Getting a car to Martha's Vineyard was not difficult. Side-wheeler ferries accommodated carriages, and cars were of similar size. Automobiles came gradually to the Vineyard. By the 1910s, the automobile had gained a foothold down-island, but only a few vehicles made their way up-island. In Gay Head, on the southwest tip of the Vineyard, "Gladys Widdiss saw her first automobile in 1920, when she was six years old. With friends she piled into a neighbor's car, Maurice Belain's, and drove 'over south.'"[77]

Chris Baer shared that, in 1916, there were 266 automobiles registered on Martha's Vineyard: 86 Fords, 58 Buicks, 25 Maxwells, 10 Cadillacs and numerous other makes. By 1922, the number of cars had grown to 681, and it was ten times that by 1936.

Service stations down-island proliferated, with Renears by Five Corners in Vineyard Haven selling Fords and Leonard's Garage, in Oak Bluffs at the present Jim's, servicing gas and oil.

Charles Shearer, a former slave, bought property in the Highlands, in Oak Bluffs, because it was near the Baptist Tabernacle. His wife opened a laundry. The Shearers established an inn, Shearer Cottage, for vacationing African Americans who were denied access to local hotels.

Shearer Cottage opened in 1912 and is still a viable business today. Over the years, many African Americans vacationed at Shearer Cottage and later bought property on the Vineyard. Prominent people, from Harry T. Burleigh to Adam Clayton Powell to Lionel Richie, vacationed at Shearer.

The Tivoli dance hall attracted people to Oak Bluffs in the early twentieth century. The twin-towered structure, built in 1907, overlooked Pay Beach and Ocean Park and housed shops on the first floor. Above was a great dance floor to entice patrons with the pleasures of a dance band and a place to savor the shoreline scene. With doors open to the ocean breeze, the Tivoli

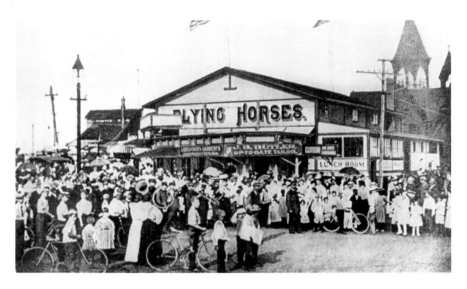

Since 1986, the Flying Horses has been under the aegis of the Martha's Vineyard Preservation Trust. The Flying Horses is the oldest continuously operated platform carousel in the country. The Vineyard Haven Band is pictured here in 1912. Today, the Flying Horses is a National Historic Landmark. *From the collection of Connie Sanborn.*

became an entertainment mecca for islanders and visitors alike. (It was torn down in 1964; today, it is the site of the Oak Bluffs Police Department.)

Composer Will Hardy brought his sextet to the Tivoli and, by 1916, had established a reputation for conducting dances at the Tivoli. Hardy wrote tunes such as "Tivoli Girl" and "Sankaty," which added to the allure of Oak Bluffs. (See *Music on Martha's Vineyard.*)

The Flying Horses carousel was built by Charles Dare for Coney Island, New York, in 1876. The carousel was transported to the Vineyard in 1884.

Skip Finley determined that the horses travel three miles per hour for twelve hours a day, providing 300,000 annual rides of fifteen revolutions; each ride lasts four and a half minutes.

A 1921 Wurlitzer band organ plays at the Flying Horses. The Preservation Trust has perforated rolls of music, with songs in music box style. "The old Stimson wind organ played only twelve songs, over and over again, when I worked there back in the 1960s," recalls Skip Finley.[78] The Flying Horses have been a treat for generations of youngsters.

Oak Bluffs offered additional attractions, including paddleboats on Sunset Lake—who knew? A pair of bowling alleys and a pool hall added to the amusement park atmosphere. Dreamland Casino, a toboggan slide and gambling supplemented the allure. A roller-skating rink operated in

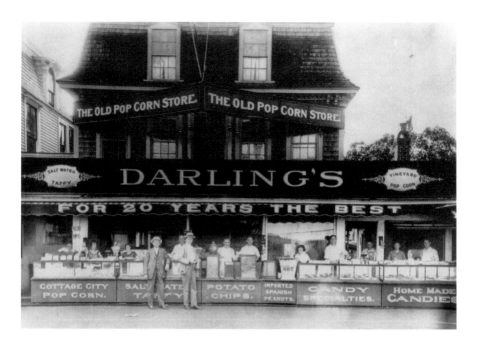

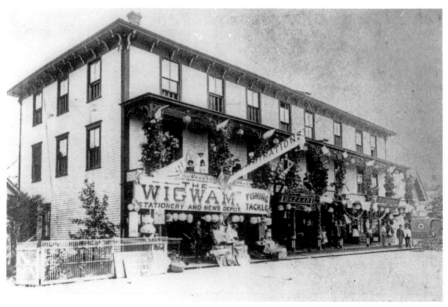

This page and opposite: Oak Bluffs became a well-known watering hole or popular gathering place around the turn of the century, with grand hotels, lively entertainment and a memorable summer atmosphere. Circuit Avenue was then, and is now, the center of activity. (Note the twin-towered Tivoli in the postcard.) *First three images are from the collection of Connie Sanborn; the fourth is a postcard.*

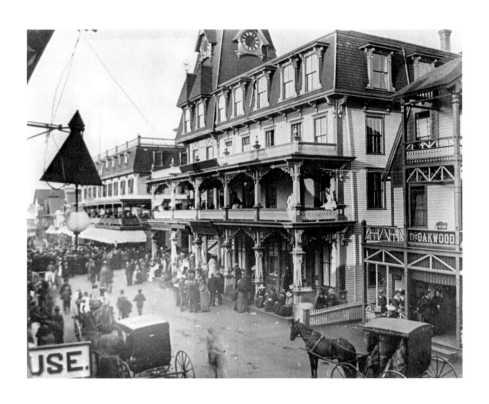

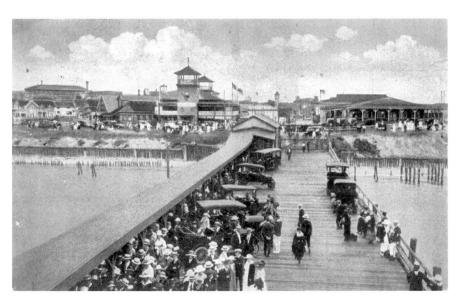

downtown Oak Bluffs, across from the Tivoli; teams of skaters played hockey on roller skates. Trotters raced at Girdlestone Park, behind the high school. Wheelmen raced bicycles. Big bands performed. Bear fighting and boxing amused the crowds.

And of course, there was roque. Roque was basically croquet on a framed clay court; the borders accommodated a carom. There were roque courts at Waban Park and the campground. The Martha's Vineyard Roque Club ran from 1881 into the 1930s.

World War I brought recognition to the Vineyard when the tiny town of Gay Head was determined to have the highest percentage of military enlistees in the state. The Gay Head population was small, but more men volunteered, per capita, than from any other town. Massachusetts governor Samuel McCall honored Gay Head with a special trip to the Vineyard in 1918, parading through the down-island towns, speaking at the Tabernacle and even motoring out to Gay Head to present the award. A plaque of this singular honor sits at the doorstep of the Aquinnah Town Hall.

A less singular event occurred off Georges Bank in mid-August 1918, when the Edgartown schooner *Progress* was sunk by a German submarine, *U-117*. The crew members of the thirty-four-ton harpooner were allowed to row their lifeboats to Cape Cod, but the ship was detonated—although according to the Hague agreement, such fishing boats were supposed to be immune from attack.

A week before an armistice was signed to end the world war, on November 2, 1918, an incident occurred off East Chop. The *Port Hunter* was laden with military supplies such as woolen socks, long underwear, soap, candles and wool puttees (to wrap a soldiers' calves). The captain of an approaching tugboat, the *Covington*, assumed the *Port Hunter* would turn away. In a horrific game of chicken, the captains misread each other, and the *Covington* rammed the *Port Hunter* and sank it right in Vineyard Sound. No injuries occurred.

The sunken *Port Hunter* became a popular site over the years, where divers recovered military supplies and nautical artifacts.

A popular illegal activity was rumrunning during Prohibition. The steamer *John Dwight* was sunk in Vineyard Sound on April 6, 1923. The *Dwight* was a rumrunner. Years later, salvage operators reported that

her deck was loaded full of barrels of Frontenac ale in bottles, the barrels being labeled flour. Her hold and her living quarters were filled with cases of whiskey. Coast Guard patrol boats ordered the salvagers away from the wreck, and depth bombs were dropped which were supposed to have destroyed ship and cargo. Many barrels of the ale were picked up, however, and enjoyed by Island residents.[79]

"One popular theory is that the Captains and perhaps some of the crew scuttled the steamer and murdered its crew in order to swindle them out of the bootlegging venture."[80]

Steamships to the Vineyard were in the news. The *Sankaty* was launched in 1911. In the winter of 1917, it left "Oak Bluffs at 1:15 in the afternoon and [did not arrive] at Nantucket until 3:15 the next morning." The trip lasted fourteen hours because it had to break ice along the route.[81]

A disastrous fire occurred in 1924. "She [*Sankaty*] caught fire at New Bedford when kerosene barrels ignited on the wharf and flames reached hay on the pier. She was cut free and drifted across the harbor, damaging the whaler *Charles W. Morgan*." The *Morgan* was saved by the Fairhaven Fire Department, but the *Sankaty* was gutted and sunk. (Months later, the *Sankaty* was raised, rebuilt and served as a mine sweeper for Canada during World War II.)

Four steamships were launched in the 1920s to meet the growing demands of tourism and vehicle traffic to the islands. The *Islander*, launched in 1923, boasted a saloon and hurricane decks and held twenty-five cars. The *Nobska* was launched in 1925. (Friends of *Nobska* tried to save it from destruction; in 1974, the *Nobska* was entered in the National Register of Historic Places and was later converted into a restaurant in Baltimore.)

The *New Bedford* was launched in 1928 and the *Naushon* in 1929. "The *Naushon* was truly the Queen of the Island Fleet, and was treated as such by any who served on her. Her brass was lovingly polished with a paste of jeweler's rouge and ammonia, a mixture far superior to any packaged concoction touted for that purpose."[82] The *Naushon* boasted thirty-six staterooms for overnight use, with hot and cold running water. (The navy appropriated both steamships during World War II.)

Steamships ran between Providence and Oak Bluffs, with a round-trip fare of $1.75, but they no longer docked in Edgartown.

Steamship crews sought union representation in 1937 and went on strike. "A steamboat strike right in the middle of the summer season was not something that the islanders were prone to take lightly."[83] Massachusetts governor Hurley had to mediate the dispute.

As more automobiles arrived on the island, roads were upgraded. The Edgartown–Vineyard Haven Road was paved in 1921, and North and South Roads were completed a decade later. Vineyarders could now shop in other towns. Macy's was at the foot of Circuit Avenue, in Oak Bluffs, in the 1800s. "The Asian-themed souvenir shop sold Chinese lanterns and goods as well as tennis shoes and postcards."[84] Macy's became Dawson's Lunch Room and then the Magnolia Restaurant in the 1920s. In 1943, Wilfred Giordano Sr. bought the Magnolia for his father's business. Today, Giordano's is a popular restaurant and serves take-out pizza.

In downtown Edgartown, Holmes Smith Grocery flourished at the site of the current Paper Store. Holmes Smith offered a variety of popular foods; some are still sold today, including Campbell's soup and Quaker oats.[85]

Dial telephones were installed in 1929, and electricity made it to Chappaquiddick five years later. However, it was not until 1951 that Gay Head and, significantly, the Gay Head light had electricity.

Cronig's Brothers grocery opened on Main Street, Vineyard Haven, and then relocated to two stores on State Road. *From the collection of Connie Sanborn.*

S.M. Mayhew ran what is now known as Alley's, in the heart of West Tisbury. *From the collection of Connie Sanborn.*

Today, Alley's sells groceries, as well as anything from fishing gear to toys, clothes, books and baked goods. *Photo by Joyce Dresser.*

Moving pictures came into their own at the Tivoli Temple in 1907. The Eagle Theatre, which opened in 1915, is now the Island Theatre. Home movies were rare. On the cusp of the Depression, the so-called Chapman film provides a snapshot of an earlier era. This film of bathers was shot on Chappy Point in 1927, giving an intimate perspective of a fun-filled summer. The old Edgartown lighthouse, with a beacon perched on the keeper's cottage, stood guard at the harbor's entrance:

> *The juxtaposition of formality and ease, of youth and old times, of wealth and rusticity encourage the viewer to get lost in the surface gloss of the Chapman film. But when the footage ends, it gives pause to ponder what the bathers in these living-is-easy old movies did not know when they were filmed.*[86]

A unique gathering place in Chilmark was the Barn House, a summer commune where prominent liberals talked through topics of the day. Participants included Roger Baldwin, a founder of the ACLU; socialist minister Norman Thomas; political commentator Walter Lippmann; poet Sylvia Plath; and Justice Felix Frankfurter, as well as actor Jimmy Cagney and artist/musician Thomas Hart Benton. The Barn House was named to the National Register of Historic Places in 2012.

THE GRIM REAPER

Tympanuchus cupido is the Latin term for a subspecies of the greater prairie chicken, known locally as the heath hen. This now-extinct bird was in the grouse family. The heath hen was a nesting ground bird, easily hunted, approximately seventeen inches long and weighing in at about two pounds.

Years ago, the heath hen was plentiful throughout the Northeast. Word is that the Pilgrims dined on heath hen, which was more plentiful than the wild turkey. The heath hen was often captured and killed, as it was unafraid of predators. It was known as a gallinaceous bird, a ground-feeding fowl—a game bird akin to wild turkey or grouse.

And it was quite numerous. In the eighteenth century, it was said that servants in Boston stipulated that they would not be served heath hen more than two or three times a week. (Were these the same servants who turned up their noses at lobster, the poor man's food? Lobsters were plentiful off New England shores.)

The heath hen flourished in colonial times, from Maine to Virginia, although the New York legislature introduced a bill in 1791 to fine hunters of the hen. As human settlement expanded, the heath hen habitat was constrained. It faced the hunter, the poacher and birds of prey, which virtually eliminated it in the United States by 1870.

Except on Martha's Vineyard. For whatever reason, the Vineyard version of the heath hen continued to breed, lay eggs and hatch offspring; it became an identifiable species, limited in population, limited in environment and on the road to extinction or extirpation.

The Massachusetts legislature created a heath hen reserve of six hundred acres on the Vineyard in 1907. This became known as the Manuel Correllus State Forest, located in the middle of the island, and it has since been expanded to some five thousand acres.

The birds were expected to go forth and multiply. Whether due to the ignorance of scientists or state legislators, the ground cover of the state forest was not conducive to the heath hen's preferred habitat: the "scrubby heathland barrens of coastal New England." By the time the heath hen reserve had been established, fewer than one hundred birds were left.

The time line toward extinction was shrinking.

By May 12, 1916, when a count was conducted, the population of heath hen had expanded to eight hundred. However, a savage wildfire burned over a fifth of the Vineyard landscape in a day, destroying the breeding ground and habitat of the heath hen. Females, protective of their eggs, sat on their nests and were burned to death. Fire was followed by a harsh winter, with unusual frost and snow. The goshawk, a bird of prey, further devastated the population. And inbreeding, with an insular population, proved a problem, without another species to dilute or expand the gene pool. (This sounds similar to the Chilmark deaf population, who married within their tight-knit community with the recessive gene for deafness.)

In an effort to preserve the heath hen for posterity, at least visually, the Massachusetts Division of Fisheries and Wildlife produced a forty-minute silent film of the Vineyard heath hen in its native habitat in 1918. In the film, the heath hen meanders amid scrub bushes and sticks, apparently making the best of things.

The film identifies the male mating habits of strutting, bowing, dancing and fighting in his lekking (breeding) grounds. "During mating season, the males made a loud booming sound by inflating the orange air sacs on their necks, a sound that could be heard as far as one mile away."[87]

The film was discovered in 2014 and is preserved in digital format. Now, scientists can "see the bird come to life."[88]

Neither the film nor the state forest protected the heath hen from extinction. Disease from domestic chickens affected the heath hen in 1921. A ban was placed on hunting; poachers captured some. A count in 1927 numbered thirteen, and only two were female. The end was in sight. "Booming Ben," the last surviving heath hen, was last seen on March 11, 1932.

The heath hen had become extinct. Or had it?

This memorial to the heath hen is in the Manuel F. Correllus State Forest. It was dedicated by the Massachusetts Department of Conservation and Recreation in 2011. The heath hen statue can be found by taking a short walk along the bike path from Gate 18 on the West Tisbury–Edgartown Road. *Photo by Joyce Dresser.*

In 2014, a project known as Revive and Restore offered genomic technology to bring back the heath hen. It would cost $250,000 to determine why the heath hen became extinct.

The project explores possible restoration of a habitat suited for the heath hen. Revive and Restore depends on research, and then the revival and restoration aspects could be considered.

Is it ethical? Is it feasible?

> *The process of de-extincting a heath hen involves taking genetic material from museum specimens and manipulating germ cells of a closely related species, in this case the prairie chicken. The prairie chicken was almost used as a source of salvation for the heath hen before, much as the Chinese chestnut saved the American one, but the state of Massachusetts denied a permit to bring the new birds to the Island.*[89]

George Church, a Harvard geneticist who works with Revive and Restore, said, "I'm particularly attracted to the heath hen because it's basically a slam dunk. We can just make a few adjustments to the DNA of the greater prairie chicken by synthesizing heath hen DNA. That would take days, thousands [of dollars], nothing. As an engineering project, birds are easy."

Revive and Restore created a chestnut tree resistant to blight; other efforts may restore the woolly mammoth and passenger pigeon. But the heath hen?

The heath hen and four other extinct North American birds—the great auk, Labrador duck, passenger pigeon and Carolina parakeet—are memorialized in "The Lost Bird Project" by Todd McGrain, an artist in residence at the Cornell Lab of Ornithology. McGrain created bronze sculptures of the five birds. Each statue is installed where the bird was last seen.

The date: September 12, 1935
The place: Lake Tashmoo, Vineyard Haven
The victim: Knight Owen
The culprit: Harold Look
The setting: Small cottages situated along the western shore of Lake Tashmoo, occupied by summer people, fishermen and a woman named Lydia Hyde, single mother to four children.

Knight Owen came from a prominent, well-to-do Vineyard Haven family. His father, William Barry Owen, founded Victor Talking Machine, aka RCA Victor, and his fox terrier, Nipper, was featured on the record company's label, cocking his ear at his master's voice. (Owen Park on Main Street Vineyard Haven is named for the senior Owen.)

Knight Owen was not in a good place. While he had served honorably as an aviator in the Great War and worked as a stockbroker, he was an alcoholic and took advantage of people. He was an arrogant playboy without focus. He frequented Harold Look's shack and drank in excess. His only paying position, at the time, was writing the town column for the *Vineyard Gazette*. (He submitted his final column, and was paid, the day he died. He used the money to get drunk.) And Owen often visited Lydia Hyde; both were from upper-class backgrounds but had fallen on hard times. She empathized with him.

Harold Look kept himself apart from others. He was an eccentric but amicable man. Look had worked at a variety of jobs, from a security guard to a railroad man. Currently, he lived in a fishing shack and controlled the runoff at Herring Creek from Lake Tashmoo into Vineyard Sound. Harold

Five Corners in Vineyard Haven. Today, this is the busiest intersection on the island, with nary a traffic light nor a policeman to assist traffic flow. *From the collection of Connie Sanborn.*

Look befriended Lydia Hyde and her four children. He resented the attention Lydia Hyde paid to Knight Owen.

At 4:30 p.m. one afternoon, Knight Owen was sitting in his Plymouth Coupe near the Hyde cottage, very drunk. Harold Look approached from the passenger's side, drew a revolver and fired a shot that grazed the car door. Owen was too inebriated to realize he was in danger. Look proceeded to fire three more shots through the car window. Owen was dead by 4:35 p.m.

Harold Look told Lydia Hyde that he had killed Knight Owen. She was distraught, as she had befriended both men.

Look turned himself in to acting police chief Simeon Pinkham.

"Going up to town, Harold? Give you a lift?" asked Pinkham.

Look said yes and got in the car. In this casual fashion, the killer was taken into police custody.

On the way, Look asked the officer to avoid his parents' house on Center Street. "Don't go by the old folks' house," he said. "They've had enough trouble."

Pinkham drove a block out of the way.[90]

Look was booked at the state police headquarters in Oak Bluffs. He was deemed incompetent to stand trial and committed to Bridgewater State Hospital for the Criminally Insane. He died there in 1964.

Murder occurred again, this time in East Chop in Oak Bluffs. In the middle of the night on June 30, 1940, one Harold Tracy, aka Jan Thomas, crept up the stairs of the Sumner dormitory of the Rice School. He broke into room #14 at the top of the first flight. When he realized the woman in bed was Mrs. Clara Smith, age seventy-two, instead of his intended lover, Marjorie Massow, age eighteen, he brutally raped and strangled her. Mrs. Smith, her hair in rollers and her teeth in a jar, put up a good fight but was no match for the lanky, limber Tracy, half her age.

Tracy had been on-island only three weeks, working at the Rice School as an itinerant electrician. He was drunk. He may have suffered a blackout. Earlier in the week, he had been admonished by Mrs. Smith for his overtures toward his young lover. Tracy attacked Mrs. Smith because he was angry at her interference—or because he had entered the wrong room. (His paramour, Miss Massow, was in the room directly above that of Mrs. Smith.)

The initial assumption by the prosecutor was that the murder had been committed by Huntingdon Rice, the reclusive brother of the head of the school. No motive was given except that Rice was "odd." Rice was jailed in Edgartown, and a trial was held at the redbrick Dukes County Courthouse in October 1940. Rice was found innocent by a jury of his peers. (See *Mystery on the Vineyard*.)

Harold Tracy was never prosecuted for the murder of Mrs. Smith. World War II was on the horizon. The death of an off-island woman was not deemed important in light of the impending threat of German submarines in Vineyard waters or Japanese planes in Vineyard skies.

WORLD WAR II ON MARTHA'S VINEYARD

By August 1941, the Vineyard found itself on the fringe of the rising threat of war. President Roosevelt arrived off Menemsha Harbor in his presidential yacht, the *Potomac*. While ostensibly fishing and enjoying the company of the prince and princess of Norway, he boarded the cruiser *Augusta* and, accompanied by six battleships, secretly steamed off to Newfoundland, leaving the press and public gawking at the *Potomac* as it sailed through the Cape Cod Canal. From the afterdeck, an FDR lookalike waved at crowds lining the canal. Roosevelt considered this elusion of the press and the public to be his finest act of deception.

It was in Newfoundland that President Roosevelt first met with Prime Minister Winston Churchill, who had likewise dodged his newspaper retinue. The two leaders conferred in meetings that resulted in the Atlantic Charter, which ensured the United States' support of Great Britain against Nazi Germany. It was key to the lead-up to the war, and Martha's Vineyard was a way station.

In the ramp-up to war, two concrete bunkers were installed in Gay Head. One has since fallen to the shore below the lighthouse; the other was filled in and now serves as an observation deck. From the bunkers, volunteers scanned the waters for German submarines off shore. German submarines, known as U-boats, roamed the ocean off the Vineyard during the war, sinking tankers and attacking convoys. From January to July 1942, fifteen German submarines passed through Vineyard waters. It was the closest the Nazis ever got to American soil.

The threat of a landing by saboteurs was real. Coastguardsmen patrolled the beaches from Gay Head to Chappaquiddick, along the south shore. No documented landings of Germans occurred on the Vineyard, although German saboteurs did land in Florida, New York and Maine.

The Signal Corps was stationed at Peaked Hill in Chilmark. They scanned the waters for submarines, sent signals between ships at sea and the mainland and utilized radar, once it functioned satisfactorily. Previously, spotting stations had been manned by volunteers scanning for enemy airplanes; radar made spotting stations obsolete.

During the war years, steamships continued service, both at home and abroad. Safeguards were put in place. Schedules were not printed for fear of saboteurs and exposing fleet movements out of Newport, Rhode Island. Passengers' cameras were confiscated. Blackout regulations were strictly followed. No smoking was permitted on deck. The steamships were painted a drab battleship gray.

Two Vineyard steamships were taken out of service in 1942, outfitted to cross the Atlantic and assigned to the British navy. The *Naushon* "became Hospital Ship #49 and worked both the [English] Channel and the North Sea," while "the *New Bedford* ran under British command between Southampton and Omaha Beach, carrying troops and supplies across the English Channel."[91] In Woods Hole, Martha's Vineyard and Nantucket, residents were proud of their steamships and flew service flags at the terminals in their honor.

The navy requested that Colby's Shipyard (today Martha's Vineyard Shipyard) build boats. Nearly one hundred small craft were constructed along Beach Road: garbage barges, troop transport vessels and seaplane tenders. Miniature boats and planes were created by the Van Ryper Shop, also in Vineyard Haven. These recognition models were used to train airplane pilots to distinguish between friendly and enemy vessels.

Perhaps the most dramatic military event that occurred on the Vineyard during the war was the invasion of the north shore. In August 1942, United States troops from Camp Edwards, on Cape Cod, boarded boats in Woods Hole and crossed Vineyard Sound in a predawn practice attack on Martha's Vineyard. Troops landed on Lambert's Cove Beach and other north shore sites. Thousands of men in hundreds of boats participated in the invasion. It was censored for the press, but locals were well aware.

A second invasion, this time properly reported, occurred in October 1942, when paratroopers dropped on the Katama airfield and troops landed along Cow Bay as well as at Lambert's Cove. Additional invasions were practiced on a smaller scale, but the initial attacks, in the fall of 1942,

were key to the eventual success of the D-Day invasion of Normandy, eighteen months later, in June 1944.

The navy built the Martha's Vineyard Naval Air Auxiliary Facility, later known as the Martha's Vineyard Airport, in 1943. It was a supplementary airfield to Quonset Field in Rhode Island. Pilots flew from the Vineyard in search of submarines, strafed and sank them and protected convoys traveling to Europe. Later, the air facility became a training center for pilots learning takeoff and landing techniques on aircraft carriers. Runways were marked the length of an aircraft carrier to practice touch and go, bounce drills and night landings. More than forty pilots died while practicing from the Martha's Vineyard Naval Air Auxiliary Facility during the war.

Bombing practice sites at Katama were used to strafe moving targets. On Noman's Land, the tiny island off Gay Head, two bombing targets were situated. Practice bombing was conducted on Squibnocket and Tisbury Great Pond, as well as at Cape Pogue on Chappaquiddick. Along the south shore and on Chappaquiddick, bombs have been recovered, still holding explosive charges. Call the police if you discover a bomb.

Off South Beach, an experimental fuel pipeline was developed in preparation for the D-Day invasion. Mile-long sections of pipe were welded together to assess the challenges of welding in water. The British developed a more successful flexible pipe, but "Edgar," as the local project was code named, was a valiant effort.

On the homefront, Vineyarders appreciated the hundreds of young men in uniform, primarily navy and coastguardsmen. Soldiers enjoyed leisure time at the USOs (United Service Organizations) in Vineyard Haven and Oak Bluffs, with a third in Edgartown. USOs offered music, books and dances. More than one romance ensued over the course of the war. (See *Martha's Vineyard in World War II.*)

After the war, the navy barracks at the airfield served as chicken coops. Quonset huts were removed for the VFW and 4-H Club. Some structures were moved off base to become humble homes. And the rest of the barracks were torn down. Today, the Martha's Vineyard Airport is the most visible reminder of the war effort on the homefront.

Remnants of the war are nestled across the Vineyard. Unexploded munitions are cached in the beaches of Katama and Chappaquiddick. Solidified sandbag fortifications lie beneath the leaves of Peaked Hill. Concrete bunkers are indiscernible yet in plain sight at Gay Head. And each town has a memorial plaque listing the hundreds of servicemen and women who went to war from Martha's Vineyard.

THE FRUGAL '50s

E ver have a hurricane on the Vineyard?

The Hurricane of 1938 was devastating because it was not forecast and wrought unprecedented destruction up and down the East Coast.

The *Vineyard Gazette* reported the impact of the hurricane in detail on September 23, 1938: "The Great New England Hurricane of 1938 tore into New York's Long Island and then Milford, Conn., and raged through Massachusetts and Vermont, leaving a path of flooded towns, flattened homes, and fires caused by downed power lines."

The account continued: "Swept by a hurricane the velocity of which has been estimated at a hundred miles an hour at brief periods, and which surpassed anything of the sort that has ever struck the Island from a southerly point, Martha's Vineyard presented a scene of disaster on Wednesday night."

Up-island, "Hariph's Creek bridge, on the Gay Head road, was destroyed, converting Gay Head and Quitsa into an island. Three of the summer homes on Stonewall Beach were washed into Quitsa Pond by the sea, and one is said to have been carried out to sea. The occupants were obliged to swim to safety, so sudden was the rise of the water, which resembled a tidal wave." The *Gazette* reported that Josephine Clarke, a local housemaid, perished in the storm.

Along the East Coast of the United States, some 564 people were killed. The hurricane swirled along the coast, reaching a top wind speed of 186 miles per hour. Water in Woods Hole rose thirteen feet. Fishing fleets were ravaged. It was "unusual for New England hurricanes in that it caused

devastation not only along the coastline, but well into the region's interior."[92] Flooding rains washed out roads and railroads all over New England. Forests were destroyed.

The Hurricane of 1944 was even more powerful. Again, the bridge on the only road to Gay Head was washed away, which necessitated that supplies and people be ferried across. The storm wrought damage and destruction in the harbor of Menemsha.

Hurricane Carol struck on August 31, 1954: "To the east, winds topping 90 mph, thundered across the Vineyard just as the summer season was cresting, with boats riding at every mooring in every Island harbor."[93] Few people were prepared for the fury of the storm.

> *The gale drives rental sailboats over a stone bulkhead and onto the flooded lawn of the Harborside Inn at Edgartown. As the froth and spume tear past their heads and shoulders, three men, wading and swimming, try to guide an overturned sloop into the courtyard invaded by an angry sea. Four others lean forward almost horizontally, hoping to shove another sailboat bow-first into the breeze, which is probably just then gusting to 70 or 80 miles an hour.*[94]

Edo Potter's silent film documented the fury of the storm and evoked awe at the force of Nature. Dramatic still shots in Menemsha capture fishing shacks tossed like a deck of cards. Boats slam into the dock or are sunk by the tempest. And in Edgartown, "catboats and the old ferry *City of Chappaquiddick* lie beached on the harbor shoreline of Chappy. Telephone poles lean over the main road, which has been torn up into chucks and washed over with sand."

On the corrugated metal wall of the Martha's Vineyard Shipyard, a high-water line marks some four feet above the roadway, noting where the ocean came ashore during Hurricane Carol.

The drama of this 1954 monster storm is seared in the memory of local inhabitants. "I remember I was just back from the service," recalls Donald Billings of Oak Bluffs. "I had just started at Terry McCarthy's place [Dockside]. And the water came in right up to the top of the numbers on the gas pump. I had an Oldsmobile up on the lift and had all the wheels off, doing a brake job, and I didn't have time to get it down, and the water came right up the lift."

His most poignant memory was when he and four other young men climbed into an aluminum outboard motorboat and rode "from the steps of what used to be Jim's Package Store (now a laundromat) out to the circle and

up to the Wesley House. Water came up and over the bulkhead. Water came right up on the street." They literally drove their boat right down New York Avenue, above and along the harbor.

He adds, "We were there in the eye of the hurricane, and it was nice and sunny and warm and so clear. And it's like someone pulled the plug out of a bathtub, the water receded like that. The second part was no big deal, just a bit of rain."

Shirley Mayhew remembers, "Hurricane Carol finally blew itself out, and in the early afternoon we got into the car and headed up to Menemsha. At that time, Menemsha was a real fishing port—one fish market, no restaurants, no grocery store and, especially, few tourists."

In her collection of essays, *Looking Back*, she described the destruction:

> *There was hardly a boat left where it had been just the day before. Masts and bowsprits stuck up out of the water to mark the graves of once-beautiful vessels. Whole boats lay smashed on Dutcher Dock, and one or two small buildings floated in the middle of the harbor. Small boats had been tossed up onto the parking lot, which now looked like an extension of the beach—sand everywhere.*[95]

Hurricane Carol was the stuff of legends. The steamship *Islander* strained against its lines in Woods Hole, rocking against the pilings:

> *Captain Alec Smith decided to take the tossing vessel to Lambert's Cove, on Martha's Vineyard. There he found a lee from the storm and was able to lay to, with his engine running slow ahead to maintain steerage. When the high water subsided, he returned the* Islander *to Woods Hole, having saved her from certain destruction.*[96]

A dozen days later, a second hurricane pummeled the Vineyard. Hurricane Edna blasted through on September 11, 1954, and was caught on film, "striking the Island more directly than Carol and splintering what was left of the splinters." In Menemsha, Everett Poole recalled, "In Edna, the eye went right over here. It went dead calm."

Diana Dozier reported, "There wasn't a breath of air. There was nothing, no wind, no sound, no water, no rain, anything. Just total silence."

Edo Potter recalled how awestruck she was

> *that the wind was blowing out to sea and we were standing there* [on Chappy] *watching it, and this cloud came over, and then it got clear. Then*

all of a sudden, without any kind of introduction, it turned and went the other way. And that really amazed me. Just as the storm came over and the other side hit. I think it was harder, but I don't think the temperature changed. That was wonderful.

The second part of the storm hit right after that. A wind gust of 120 miles per hour was recorded at the airport in that second wave of the second hurricane.[97]

Tom Dunlop continues his hurricane review: "After Carol and Edna in 1954, no true hurricane assailed the Vineyard until Bob on August 19, 1991, and no other has struck in the 23 years since." Hurricane Bob and the No-Name Storm created havoc and destruction across the Vineyard. Those storms were forecast, to some degree, yet still caused power outages and devastating damage. Hurricane Irene blew by in 2011, and Superstorm Sandy left its mark, but not to the degree of earlier storms that deluged the Vineyard with pelting rain and a rising ocean.

In another, calmer tone, Skip Finley captures the back-story of the Polar Bears: "The irony and incongruity of Oak Bluffs is simply delicious, not just today, but over the years. It's ironic to live in a town where the Polar Bears are black, for example."[98] The name? Some say it originated in a group from Coney Island formed in 1903. Others say its genesis came when the staff of the *Amsterdam News* rented a house in Oak Bluffs; their newspaper ink formed the inkwell. The Polar Bears enjoy swimming at the Inkwell Beach throughout the summer. Sometimes it's swimming, sometimes it's singing and always it's very social.

And of course, frozen water lends itself to a story, too. Donald Billings remembers when Vineyard Haven Harbor was frozen:

I skated from here on Lagoon Road, there was four of us, across the Lagoon, over the wall and started skating on the ocean side. We heard the siren blow, and it was the chief of police of Vineyard Haven. He could see the ice [wavering], and so we came back in. They had ordered a couple of boats to come and break the ice.

In earlier days, steamboats were heavier and able to break the ice.

It is rare but not unheard of for Vineyard Haven Harbor to freeze over. Edgartown Harbor was frozen in 1917 and again in 1934; people could skate to Chappaquiddick. *From the collection of Connie Sanborn.*

When he was young, Donald Billings recalls, the snow was so high at Healey Plaza that he and his friends tunneled from the post office through to Ocean Park. Youngsters turned the snow to their economic advantage:

> *When I was a kid, twelve or thirteen, we would wait to see at six o'clock if the fire horn blew in a snowstorm. And if it blew, I think it was either 3-3 or 6-6, we knew there was no school. We got up and got dressed and went right down to the fire barn and opened it up for shoveling. They'd take a bunch [of kids] and do Main Street, both sides, and then go shovel out the hydrants.*

And where there's water, there are fish. From the 1950s to the 1970s, Herb Slater of Menemsha was a harpoon sword fisherman aboard his *Aloysius,* "a former rum-runner with a saloon cabin amidships and a tall mast and pulpit added for the chase whose most important and enduring catch was his wife Jane," wrote Peter McGhee.[99]

Mr. McGhee shared a fisherman's tale:

> *These men were hunter-gatherers, fiercely competitive and secretive about their plans. They rarely fished in sight of one another. Their radio "chats"*

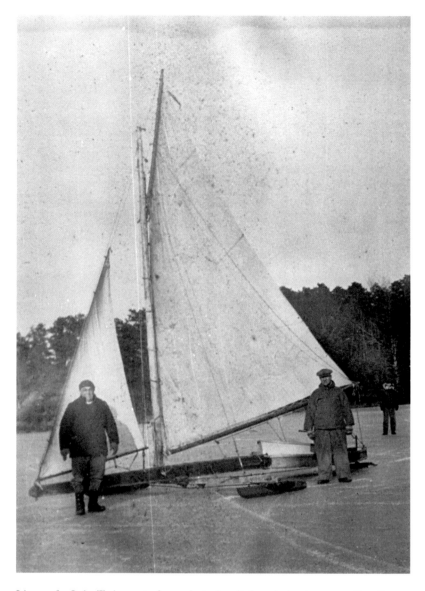

It's rare for Lake Tashmoo to freeze, but when it does, iceboats appear. *From the collection of Connie Sanborn.*

were studies in non-communication. "Not much doing here; think we might try going to the west'ard some." "Not much" might mean two or three fish on deck and another struck and still in the water. "West'ard" could mean east or north or south.[100]

From hunting with a harpoon to hunting with a rifle, Donald Billings recalls, "hunting was pretty popular. Deer was meat for winter. We used to hunt rabbits, quail, pheasant and ducks." Of the economic struggles of the 1950s, he says, "We used to hunt up-island because we took care of them [caretaking the houses]. Live off the land. You could go off East Chop and find loads of boats all lined up, catching fish. Lot of Portuguese went fishing, came back and gave it away."

And gardens: "Everybody had their gardens, gardens everywhere. A lot of people grew a lot of flowers and vegetables, and the kids, in the summertime, would take and load their wagon or cart and go down through the campground and down to the harbor and sell their flowers to make money."

The link between the Vineyard and the mainland has been the steamship: "Even on Nantucket and the Vineyard where history is ingrained and lives as much as the past can, it is difficult to be as conscious as one would like to be of the courage and foresight that resulted in the steamer lifeline to the islands."[101] Whether the harbor was frozen, supplies were running low or people needed to get "off the rock" for medical or personal reasons, the steamship was the means to that end.

In 1947, Governor Paul Dever signed a bill for the takeover of the island steamship line (Massachusetts Steamship Line) by the New Bedford, Woods Hole, Martha's Vineyard and Nantucket Steamship Authority. This was the genesis of the current Steamship Authority.

While more costly to build, double-ender ferries make docking easier, handle severe weather by not having to turn around and do not require reversed direction with mechanical failure. When the double-ender *Islander* was launched in 1950, it set the stage for a half century of superb service to the Vineyard from Woods Hole.

Cost is a primary factor in building a ferry. The *Uncatena* was launched in 1965, but cost curtailed its size. Eight years later, in 1973, the passenger boat was lengthened by inserting a middle section. "She is now 52.5 feet longer than at her appearance in 1965, her original construction being held to 149 feet because of limited funds."[102] The *MV Nantucket* was launched in 1974 with a capacity of one thousand passengers and sixty automobiles.

The *Island Home* is the newest steamship in the fleet, a double-ender launched in 2007, with a capacity of 1,200 passengers and seventy-six vehicles. *Photo by Joyce Dresser.*

A labor dispute erupted into the longest steamship strike in history:

> *On April 15, 1960, the crews on all of the steamers went on strike again. Two weeks previous to this, the crew of the* Nantucket *had refused to make the trip from New Bedford. The reason for this was because the* Nobska *had been taken off the run and was replaced by the* Nantucket, *manned with only one and a half crews instead of a complete double crew.*
>
> *As days turned into weeks, the strike over the manning of the boat line vessels continued in effect with no sign of settlement.*[103]

The *Edna Fae* of Gloucester brought over a barge with freight; small fishing boats and private excursion vessels stepped in to "help beleaguered residents on the islands." Eventually, after more than two months, "the strike ended, but not the heat that it had generated among the islanders."[104]

This was the longest strike in steamship history: seventy-seven days. It ended when the state legislature passed a bill that reorganized the Steamship Authority, empowering it to operate the boat line out of Woods Hole and

Vineyard Haven's Main Street used to be two-way, with parallel parking, until the mid-1960s. It looks busy in this postcard image, but nothing like today.

Hyannis, not New Bedford. The service was created to provide "adequate transportation of persons and necessaries of life for the Islands of Nantucket and Martha's Vineyard."

Donald Billings recalls that in the '50s, "you knew just about everybody because we had the bowling alley. There was always teams from everywhere." Also, "all the schools had basketball in the three towns, in Edgartown, Vineyard Haven and Oak Bluffs. That's the big thing having basketball. [It's] how you connect with each other." Baseball was another way to bring people together: "We played all three towns, because everyone had a park." And there was a fall dance at the old gym; dances brought people together. "When the kids got to fifteen years old, they didn't graduate; they had to go to work." He remembered the 4-H Club was big.

His wife, Nancy, adds, "Things were different with the church. We used to have a big Christmas party with the church. We had auctions and sales by the churches. All the Chilmark people came down."

She remembered license plates: "You knew it was an island person; everyone had the same three letters to designate an island car. For twenty years, that was the system: the last three digits were letters denoting Martha's Vineyard."

Donald Billings mentioned the importance of family time. We had "pretty tight friendships and relationships with others." After World War II, there

was a lot of diversity. His mother held a sewing club with women who came to the Vineyard from "Germany, England, Poland, Italy, and Portugal. [The women were] all here because they married people on the Vineyard."

He recalls a unique experience: "Moving a house, haul it with horses. Roll the house along on logs—haul it to a new place. Jack it up with rocks and put timbers and set the house down, and [a] fellow runs along the side and puts the timbers underneath." Nowadays, a new owner demolishes his house and builds whatever he has in mind. In a simpler era, the house was valued, preserved and relocated.

———

An important job in the postwar era was roadwork, as more cars arrived on the Vineyard. Donald Billings found himself building Moshup Trail, out in Gay Head: "We started at the upper end. Eddie Smith had a plant down here in Farm Neck, and he made asphalt, and he got the first part of the contract." He goes on: "It was tough on the first part because it was all beach sand, and we had to haul it out. Lorenzo Jeffers's pit was right in Gay Head. We started that in '54 or '55."

Another project was dumping fill to shore up the bluffs along East Chop Drive in Oak Bluffs:

> *We started carting stone out of Seven Gates Farm. We blasted the stone; we'd cart the stone. Inside it was like a quarry. Every year, you'd go in and blast a different place and cover it up when it was done. Lot of stone came out of there. We'd drop it over the bank. [We had] only single-axle trucks and dropped the stone over the top. Used a lot of the rock to make the jetty. All the way down along the shore to the lighthouse, right along the water. In trouble now because they didn't take care of it. They put the cap on it, so you could walk across it. And now the cliffs are eroding.*

———

At the Shearer Summer Theatre, actors were neither unionized nor paid and literally worked through their vacations.

In the years following World War II, the Shearer Summer Theatre was one of the first summer theater groups on the island. It was founded by Liz

White. Friends and family made up the repertory effort, which presented performances at the old Oak Bluffs School in 1946 and, later, at Twin Cottage in the Highlands.

Friends from New York visited the Vineyard for a three-week vacation. They were enticed, or invited, to participate in the Shearer Summer Theatre. Over the course of six years, Liz White produced ten plays on the Vineyard. One of Liz White's close friends was Cutie Bowles, mother of Olive Tomlinson. Cutie was very involved in the productions; her husband, William Bowles, took photographs of the performances. And daughter Olive was in the first play, *The Women*, at a young age.

Olive Tomlinson lists the plays: "*The Slab Town Convention, Lysistrata, Anna Lucasta, Angel Street* and *If Men Played Cards as Women Do, Cooling Waters* and some others. People were on vacation—I have photos of them sitting on the beach rehearsing. And I know at night they rehearsed. It can't be more than three weeks."

She continues:

> *Liz White wrote a play of her own called* Cooling Waters. *And it was a play about slavery. And I think I can speak for my contemporary, Gail Jackson, Liz's niece, and I—we didn't approve. We didn't want to have anything to do with it. I was at that prickly age when I didn't want to have anything to do with slavery.*

As Linsey Lee noted, "Shearer Summer Theatre productions declined in the early 1960s, as Liz focused her energy on producing an adaptation of Shakespeare's *Othello*, filmed partially on the Vineyard." That production was eventually filmed and has been shown on occasion on the island.[105]

Villa Rosa in Oak Bluffs was where prominent African Americans gathered. A plaque on the house, placed by the African American Trail, notes, "This house served as the summer white house for the leaders of the civil rights movement who stayed here as guests of the Overton family." Guests included Harry Belafonte, Jesse Jackson, Dr. Martin Luther King, Joe Louis, Malcolm X, Adam Clayton Powell Jr. and J. Philip Randolph. The Overton House, which overlooks Nantucket Sound, is a prominent site on the African American Trail.

Chapter 14

THE SINGING '60s

The 1960s were memorable, regardless of where you lived. A poignant Vineyard memory was the Moon Cusser Café, which opened in the summer of 1963 in a former grocery store, now Basics, the clothing store on Circuit Avenue in Oak Bluffs. It was the early 1960s—before the Beatles, before rock went electric, before the travesty and tragedy of a decade now seared deep in the collective conscience.

The Moon Cusser was a folkies' hangout, a coffee shop that offered top-of-the-line musicians and a chance for talented amateurs to take the stage. A moon cusser was a pirate who lured unsuspecting sailors to steer their boat ashore with a lantern, mistaken for the moon. When the boat ran aground, the thief stole the cargo. The logo for the Moon Cusser Café was a lantern.

For Vineyard baby boomers, the Moon Cusser was special. The café offered musical acts, up close and personal. It was a place where people "could feed their growing interest in folk music, listening to some of the best folk and blues musicians of the time."[106]

Dave Lyman reveled in his role as manager of the Moon Cusser: "This was a seven-day-a-week job, but the work was not really work. We loved what we were doing." As Lyman posted on his website: "I can still see the two Simon sisters [Carly and Lucy] standing there in the spotlight, each in a matching delicate white dress, with a guitar, singing 'Winking, Blinking and Nod.'" Carly Simon recalled her Moon Cusser days: "It was thrilling. It was absolutely thrilling. It was the biggest thing that had ever happened to me."

Tom Rush adds, "I do recall that the Moon Cusser had a guesthouse for visiting artists, and one might well overlap for a few days with musicians coming in ahead of their engagement. I remember getting some hang time with Mississippi John Hurt one year, Ian and Sylvia (Oh, Sylvia!) the next."

"We'd catch a ride down to Circuit Avenue to the Moon Cusser," recalls Kate Taylor, sister of the singer James Taylor. "This was Mecca for us. There were many wonderful blues, folk and bluegrass acts on the touring circuit in those days. We could see Josh White Jr., Doc Watson, the Simon sisters, Jim Kweskin and the Jug Band, John Hammond, Eric Anderson, Phil Ochs. This was one rich scene."

Kate speaks for many baby boomers when she says, "We knew we had it good, but we had no way of knowing just how precious and golden that era really was."

The Moon Cusser was a memorable experience for those who enjoyed it. At the opposite end of the spectrum—and the decade—was an automobile accident with national implications. We must acknowledge the infamous Dike Bridge, located over a stretch of water on the island of Chappaquiddick, across Edgartown Harbor.

First, the back story: New York senator Robert Kennedy leapt into the presidential fray in the spring of 1968. He decided to run for president after Minnesota senator Eugene McCarthy upset President Lyndon Johnson in the New Hampshire primary. President Johnson announced that he would not run for reelection. Thus, Kennedy and McCarthy faced off in several primaries, seeking delegates for the Democratic convention. The final primary was on June 4 in California. Kennedy won.

Immediately following his acceptance speech, Sirhan Sirhan shot Robert Kennedy, who lingered in limbo for hours but died on June 6, 1968. His family was heartbroken. His staff was devastated. The country was shocked.

One member of his staff was Mary Jo Kopechne, a twenty-eight-year-old Pennsylvania woman, one of the so-called boiler-room assistants.

A little over a year later, Massachusetts senator Ted Kennedy, Robert's brother, invited former staffers to a party in a cabin on the remote island of Chappaquiddick. The date was July 18, 1969. Late that night, or early the next morning, Senator Kennedy, with Mary Jo in the front seat of his 1967

Oldsmobile, turned onto the narrow wooden Dike Bridge. The car plunged over the side of the bridge and was quickly submerged in Poucha Pond.

"Kennedy would later claim that he made repeated attempts to rescue his companion by diving into the water." He then walked a mile or more to the ferry slip by Edgartown Harbor. The ferry was not running. Kennedy stated that he "swam five hundred yards across the channel, walked to his hotel room and collapsed in bed."[107]

As the *Vineyard Gazette* summarized the weekend in its edition of July 22, 1969:

> *Many persons on the Island, when they heard the news, expressed their dismay over yet another fateful incident in a series seemingly designed for a Greek tragedy afflicting the Kennedy family. As the weekend progressed, the dismay was intensified by the hungering newsmen, who, in the process of searching out every scrap of fact, turned a usually routine procedure, Chief Arena's walk across Main Street yesterday to register the complaint, into a crowd scene worthy of Cecil B. DeMille.*

Kennedy's accident put Martha's Vineyard, and specifically Chappaquiddick, in large bold font in the national headlines. In the decades since the accident, it has been reviewed, investigated, discussed and analyzed ad infinitum. Those are the facts, and that is the story, to the best of our knowledge.

In recognition of the 300th anniversary of the town of Tisbury, celebrated actress and summer resident Katharine Cornell and her partner, Nancy Hamilton, prepared a documentary of the town. They spliced some thirty old home movies into a praise-worthy, historical motif, which celebrated not just Vineyard Haven but also the beauty, charm and ambiance of the island as a whole. The movie debuted in August 1971 as a fundraiser for Association Hall, now the Katharine Cornell Theatre. *This Is Our Island* is a rare and remarkable review of the Vineyard, narrated by Miss Cornell herself.

THE SWINGING '70s

John Abrams moved to Martha's Vineyard in the mid-1970s to build a house in Chilmark. "We thought we'd be done with the house in about six months and have a pocketful of money and head back to Vermont," Mr. Abrams told Ivy Ashe from his office at the South Mountain Company. Once he got settled on the Vineyard, there was no need to leave.

"Since 1970, the year-round population of Martha's Vineyard has more than doubled, far outpacing the rate of growth in Massachusetts and that of the United States," reported the *Vineyard Gazette*. Based on census data, 271 people relocated to the Vineyard in the 1960s. That number increased tenfold, to 2,845 new residents on the Vineyard, in the 1970s.

(This was the first big growth spurt of the Vineyard. A second expansion occurred during the Clinton administration in the 1990s, when trophy homes were built by an upper-class population who discovered the Vineyard.)

"The influx of people was never as great as the wave that crested here in the 1970s," wrote Ivy Ashe.

> *The baby boomer generation was on the move, and the nature of the Vineyard was changing. The back-to-the-land movement had landed, challenging the politics of the old guard, as was happening in many places, and sunbathing naked on Jungle Beach, as was not. But the 1970s wave was something deeper than that, tapping into the enormous reserve of potential stockpiled in the late 1960s.*[108]

The Vineyard became a haven for those seeking a safe preserve, an outlying, undiscovered opportunity apart, yet part, of the country. "Land preservation, explosion of the arts and music scene, stepping back from industrialization—it all happened on the Vineyard in the 1970s."[109] This rapid growth sparked conservation efforts to protect and preserve the Vineyard as it was.

Within the decade, the Yard dance program, the West Tisbury Farmers' Market, the regulatory Martha's Vineyard Commission and the Hot Tin Roof all came into existence. It was the 1970s, and "people came to the Vineyard, and stayed on the Vineyard because they could do what they loved. They could make it work."[110]

Cheryl Stark taught jewelry making at the Island Craft Center in Vineyard Haven in the 1960s and opened her popular store in 1971, in what now is the Black Dog Bakery. Hers was the first jewelry store on the island.

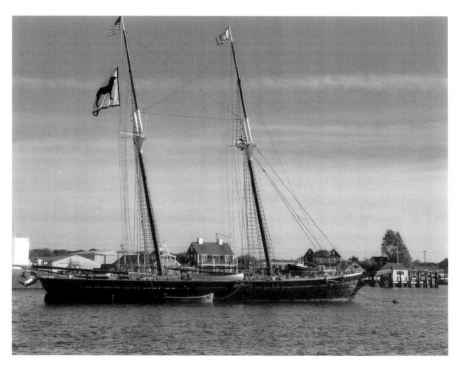

In 1964, Captain Bob Douglas designed the *Shenandoah*. It has no engine; thus, it is totally dependent on the wind. The *Shenandoah* keeps sailing alive on the Vineyard. In 1971, Captain Douglas opened the Black Dog Tavern, one of the first year-round island restaurants. *Photo by Joyce Dresser.*

Jaime Hamlin came to the Vineyard to work on *Jaws* in 1974 and went on to develop her successful catering business. Anna Edey founded the Art Workers' Guild with fellow weavers. James Taylor and Carly Simon were married in 1972 and raised their two children part time on the island.

The No Nukes Concert was held in September 1978 on the Allen Farm in Chilmark and drew over seven thousand people. The effort was designed to restrict expansion of the Plymouth nuclear power plant. Carly Simon, Kate Taylor and Alex Taylor performed, along with John Hall and the Pousette Dart Band. Shortly thereafter, in 1979, George Brush and Herb Putnam enticed Carly Simon to join in the creation of the popular Hot Tin Roof, which promoted the sound of the era.

The first time Nat and Pam Benjamin sailed into Vineyard Haven Harbor, he said, "We went ashore, and the *Rosa rugosa* were in bloom, and the beach plum, and Pam immediately said, 'This looks pretty good.'" He worked at the Martha's Vineyard Shipyard, and she worked at Fred Fisher's Nip 'n' Tuck Dairy. Pam Benjamin was instrumental in forming the Vineyard Montessori School in 1974; Nat Benjamin and Ross Gannon began their wooden boat–building business in 1980.

An Island Plan developed by the Martha's Vineyard Commission noted that "the Vineyard's workforce is nontraditional and entrepreneurial."

Jan Pogue of Edgartown observed, "It's so fun to see how the Vineyard has been shaped by these creative and individualistic people. And it's reassuring to know that it really is still going on—young farmers and chefs and artists are creating the next 'new' Vineyard."

Polly Simpkins of Vineyard Haven added, "This same Vineyard consciousness and spirit that remains today continually reminds me that there is no better place to live authentically and openly, inspired by an amazing island community of visionaries, thinkers and people just being themselves."

Two unique events occurred on the Vineyard in the 1970s. One was the filming of the movie *Jaws*, the first summer blockbuster movie, which again put Martha's Vineyard on the map but in a more positive light than the Dike Bridge. The second was the effort by Vineyarders to secede from Massachusetts due to their loss of representation in the General Court. Both events garnered publicity and pleasure for Vineyarders and established a public perception that made the island appear larger than life.

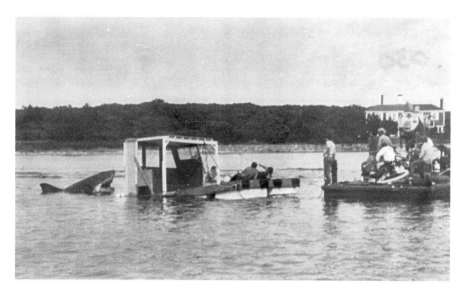

This page: Making the movie *Jaws*, as author Peter Benchley recalled, was a challenge. It was filmed on the open sea, albeit near shore. Three models of the shark were created, each weighing nearly one ton. One model was the left side, another the right and the third was a complete shark. *From the collection of Connie Sanborn.*

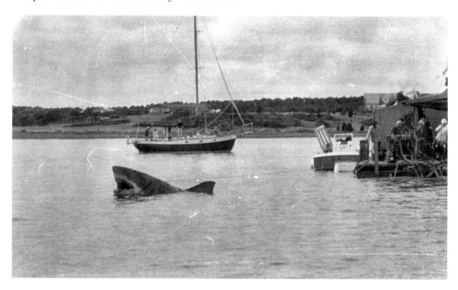

Peter Benchley, author of *Jaws*, recalls rereading Carl Gottleib's *The Jaws Log* in preparation for writing about the thirtieth anniversary of the movie in 2005. He planned to skim the book but was immediately hooked: "I couldn't put it down till I had read it straight through to the endnotes and final

credits, for I found myself awash in vivid memories of the most astonishing, tumultuous and momentous months of my life."

Benchley's book was published in 1973 and quickly considered for a movie. Universal Studios shot the movie from May through September 1974, and it was released in the late spring of 1975. Benchley was on the set in 1974, with twenty-six-year-old Steven Spielberg, when the movie was filmed on Martha's Vineyard.

Benchley recalled that experience: "All of us, however, knew that we were witnessing something memorable, exciting, probably unprecedented and, at times, altogether weird."[111]

"Unfortunately, due to the press of the schedule and the brisk start, Bruce [as the shark was nicknamed], had never been tested in ocean water," noted co-screenwriter Gottleib. The shark's paint failed to stick to his skin. The electronic sensing devices designed to report shark speed and position did not work. "Thanks to a complicated ocean process called electrolysis and the steady diet of salt air and moisture, they [the electronic sensor devices] had burned out weeks before; everything had to be operated by sight or instinct."[112] It proved a daunting experience.

The critical part of the story, when the audience is deeply immersed in the drama, revolves around Alex Kintner, who was in the water when he was attacked by the shark. Alex was played by Jeffrey Voorhees, who survived stardom to grow up and manage the Wharf in Edgartown. In the movie, his mother was played by Lee Fierro.

Gottleib respected Lee Fierro,

> *a local talent whose dialogue was rewritten a day before her scene was filmed. A former professional actress who left New York to raise a family in more bucolic surroundings, she objected to the profanity in the original drafts, and Steven wanted something more suited to her Everywoman looks. After the film, she returned to the stage to the degree that she co-founded the Island Theater Workshop on Martha's Vineyard, in which she continues to be active.*[113]

We talked with Lee Fierro about *Jaws*: "I wouldn't say I was a featured player, but I was in it. And it lives on and on. It's always on TV."

As an actress, she recalls, "at the time I was not nervous. I was only partly engaged in the whole process. I wasn't taking it too seriously. In fact, after I was given the role, I turned it down, as I would have to use swear words. I said, 'I can't do that.'"

She continues: "They spent the weekend looking for someone else to play the part. Then they said they thought I might be right, and the screenwriter wrote an alternate version. On Monday morning, they said, 'If you don't have to do any swear words, would you do the role?' And I did."

Her most memorable moment in *Jaws* was the confrontation with the police chief: "As for slapping Roy Schneider's face, I felt sorry for him, but it was a job to do, so I did it. He was not particularly friendly toward me at all. Shortly before he died, he was interviewed and sent me a message, which explained that he acted that way because he knew he'd be slapped."

Life went on for Lee Fierro: "I did it [the movie], and it was over. And I was more interested in it afterward. It was a big deal in a way, after it was over. No one ever expected it to turn into this iconic piece."

She recalls the thirtieth anniversary of the release of *Jaws* in 2005:

> *People would come from all over the world, I mean everywhere. And I saw the movie on a big screen at Owen Park. I was really impressed by the quality of the movie. Nowadays, everything is done digitally. This movie was real. They had to have a fake shark, but nothing else was false. Compared to what's going on nowadays,* Jaws *was real.* [114]

Filming wrapped in September 1974. Over 400,000 feet of film was edited down to 11,000 feet. John Williams of the Boston Pops composed the haunting soundtrack, which dramatically evoked the shark's movements. *Jaws* was released in the spring of 1975.

The movie took twice as long to film as scheduled and cost twice the anticipated budget, with a final cost of some $7 million. Yet *Jaws* opened to rave reviews and box office acclaim and became a very successful movie, putting Martha's Vineyard on the front page, raking in millions of dollars for Universal Studios and, over the years, generating thousands of dollars for local actors and actresses. It ensured Steven Spielberg's reputation and spawned *Jaws 2* and *Jaws 3*.

Three years later, the *Vineyard Gazette* chronicled the filming of *Jaws 2*: "On Monday *Jaws 2* was back cluttering up Edgartown with cables, trucks, extras and all the wonderful paraphernalia used in the world of illusion." The *Gazette* whimsically appreciated the Hollywood touch: "Marvelous portable antique gas lanterns materialized on the street where they haven't been in years (they were even lighted at night), and replaceable meandering trees appeared."

Apparently, Universal Studios had trouble with the trees: "Now they are shooting hot summer in the middle of October." Obviously, the trees

needed more leaves to look realistic—hence the portable trees, fresh from a local greenhouse.

Change was evident. Signs went up as the Amity National Bank replaced Edgartown National Bank. Fifty extras were employed to create the busy mid-summer atmosphere of a crowded throng milling about on the sidewalks of Edgartown. By the end of the shoot, a sloop was docked on the windward side of the wharf. The *Gazette* observed dryly, "*Jaws* has an affinity for sailboats docking on the wrong sides of docks."[115]

A less dramatic theatrical experience began on the Vineyard in the 1960s and flourished in the able hands of Lee Fierro, who had a role in *Jaws*. Mary Payne, a feisty, talented director, founded the Island Theatre Workshop in 1968 to offer a summer program for children. Lee Fierro became associate artistic director in the 1970s, joining Mary Payne to form a united front. Mary wrote lyrics and a story line, while Lee composed the music. While Mary directed, Lee performed on stage and later directed adult plays and musicals.

A meeting of actors, technicians and others of the Island Theatre Workshop "voted a statement of philosophy redefining the Workshop as being like a guild of performing artists, technical personnel, and a school."[116]

Mary Payne's cousin Nancy Luedeman assisted in play production for many years. Gayle Stiller performed in some of the early productions as Elizabeth Barrett Browning. Jaimie Harris has participated in productions for decades.

Today, the summer Children's Theatre attracts enthusiastic musical theater directors and college students who create original pieces. "This very special theatre program for young people, for both year round and seasonal residents and visitors, includes acting, singing, dance, theatre games, improvisation and beach days."[117]

While the Island Theatre Workshop (ITW) has never had its own facility, it finds itself welcome across the Vineyard and has performed off-island on occasion. ITW is an incorporated nonprofit organization. Lee Fierro became artistic director on the death of Mary Payne in 1996. Kevin Ryan has assumed a role in many productions.

"Island Theatre Workshop and all of its wonderful programs continue to thrive—to sing, and dance—to offer adults and children alike an education and a place to stretch their imaginations in a fun and nurturing environment for all."[118]

Outside the Oak Bluffs post office were two mailboxes. One read, "Island Mail." The other was designated to "America and Beyond."

In the late 1970s, the Massachusetts government deemed it imperative to reduce the number of state legislators to expedite functions of the statehouse. A redistricting bill was proposed to consolidate areas of the state with more limited populations. This had a direct impact on the residents of Martha's Vineyard. "The bill would have deprived Dukes County (including the Vineyard and Elizabeth Islands) and Nantucket County of separate representation in the State House."[119]

At the time, the average size of a district in Massachusetts was ten thousand voters. With only two thousand voters on Nantucket and four thousand on the Vineyard, the islands were considered too small to warrant individual representatives, although this had been policy since the 1600s. As recently as 1968, the Supreme Judicial Court affirmed representation for Nantucket and the Vineyard.

Nevertheless, in the first week of 1977, the "Legislative Committee on Redistricting held a surprise hearing on a plan to amalgamate Dukes and Nantucket Counties with the outer Cape towns of Chatham, Eastham, Orleans, Truro and Wellfleet, under one legislator."[120] Twelve thousand residents of the islands would be combined into a district with twenty-four thousand residents on Cape Cod.

"The Islanders were angry at their disenfranchisement, no doubt about it."[121]

A movement for secession spread rapidly across the Vineyard. If representation were denied, the Vineyard would secede from the state of Massachusetts. It was that simple. It was that stark. It was that serious. The outrage was real.

Selectman Everett Poole of Chilmark was quoted as saying, "By the state constitution, the Islands have always been assured of representation in the General Court. If they want to take that away from us, then the hell with them. We'll set up another state." Leaving the United States was not the primary point. Vineyarders wanted out of Massachusetts.

It was bandied about that when Thomas Mayhew purchased the Vineyard in 1642, it was to escape the politics of the colony in the mid-1600s, yet he was still accorded representation in the colonial legislature.

"The redistricting bill," the *Vineyard Gazette* thundered on March 4, 1977, would be "in the clearest and simplest terms a denial of the basic principles of democracy."[122] People talked seriously about the movement to secede.

Town selectmen voted to secede. Nantucket supported secession by a vote of four to one. A bill was introduced in the statehouse proposing secession from Massachusetts. Vineyard representative Terence McCarthy of Oak Bluffs documented pensions, finances and trade licensing under the proposed new status of statehood.

An interim cabinet was named. Barbara St. Pierre Hotchkiss wrote an anthem for Martha's Vineyard. Fran Forman, a member of a Cambridge chapter that supported the Vineyard, designed a flag, currently emblazoned on the signpost of the Harbor Landing in Vineyard Haven. The flag depicted a seagull aloft, with an orange sun setting on a dark blue background. A copy of the flag was presented to Representative McCarthy, who would lose his seat if redistricting passed. The flag is housed in the archives of the Martha's Vineyard Museum.

Senator Ted Kennedy recognized the discontent of Vineyarders and "the deep sense of frustration of Island residents as a result of the loss of their seat in the House of Representatives of the Great Court." Governor Michael Dukakis, however, made it clear that if the secession bill were to pass, he would veto it.

New England states all offered encouragement. The state of Hawaii added moral support. John Alley says, "I guess they all did it for reasons of personal or state publicity." And there was a good amount of public discussion on the matter. It made the NBC nightly news.

Although the voters of Nantucket and Martha's Vineyard did not get their representative back, the General Court did gain an understanding of the unique status of the islands, which were awarded an aide to promote the wants and needs of the island populace.

And the Vineyard garnered a good deal of publicity, with sound democratic principles aired about taxation without representation. John Alley says, "In retrospect, if we had another opportunity, I think we'd do it again." For Alley and his fellow participants, it was "a heck of a lot of fun and a textbook example of how to run a public relations campaign."

As Mike Seccombe observed, "The spirit is there every time an Islander colloquially refers to the act of taking a trip off-island as 'going to America.'"

Redistricting got the Vineyarders' backs up. Soon, another movement caught the attention of the locals. The unlikely effort to deny McDonald's an island site gained traction as more people got involved. "Presented

with a petition bearing 1,500 signatures Monday night, Mr. Harrington [representing McDonald's] said the petition didn't mean anything. 'You can collect signatures against anything, and most of the people don't know or care what it is they're signing.'"[123] Turns out, Vineyarders did care what they were signing.

The *Martha's Vineyard Times* continued, "The crowd which pressed around him and the two McDonald's officials included the young and the old, the staid and the silly, in all manner of dress." Board of Health chairman Dr. Michael Jacobs was quoted as saying that the "board was not there 'to pass judgment on McDonald's,' but only to consider a septic system, and he stuck to that point throughout." Furthermore, "Dr. Jacobs said that a preliminary examination of the plan indicated it meets neither the town nor state health codes."

Prominent local people such as Carly Simon became involved in the protest. "She was part of a small group including James Taylor—who[m] she was married to at the time—that stopped McDonald's from establishing here," wrote Matthew Perzanowski.[124] "The small group stood at 5 corners (while all the magazines like *People* came to film) sending the message that they didn't want McDonald's here because it doesn't have the feeling of the Island."

Ronald McDonald was hanged in effigy. Bumper stickers were plastered across the island, with succinct wording: "Keep Mac off Martha." Today, there are no McDonald's, Burger King or Wendy's fast-food shops on the Vineyard. Nor are there many chain stores. Dairy Queen snuck in under the wire, Radio Shack and NAPA have outlets and Stop & Shop made its way onto the Vineyard shores, but few beyond that.

LAND MANAGEMENT, PART 2

A hallmark of the beauty of Martha's Vineyard is its natural environment, with a climate cooler in the summer and warmer in the winter than that of the mainland, thanks to the adjacent Gulf Stream that flows off the eastern shore. Granted, it is an island—third largest off the eastern coast of the United States. Yes, there is ocean all around and limited access. Remnants of the glacial terminal moraine remain. And the land mass is only ninety-three square miles. So there is a quantifiable amount of property that constitutes the natural beauty of Martha's Vineyard. Vineyarders seek to preserve and protect this pristine piece of paradise.

Land conservation became a priority in the later half of the twentieth century. The threat of unregulated development led to a legislative act that spawned the Martha's Vineyard Commission, the regional planning and regulatory agency of Dukes County, which includes the six Vineyard towns as well as Gosnold on Cuttyhunk in the Elizabeth Islands.

The back story is that Senator Ted Kennedy, working with authors William and Rose Styron and *Gazette* editor Henry Beetle Hough, proposed the Island Trust Bill to thwart development on Nantucket and Martha's Vineyard.

While the Kennedy bill failed to pass, it spurred comparable legislation, known as the Land Use Control Act. That bill, passed in 1974, led to the formation of the Martha's Vineyard Commission, which has successfully limited or curtailed development to preserve open land for future generations.

The goal of the commission is to protect the "natural, historical, ecological, scientific, [and] cultural" qualities of the Vineyard, as well

as to manage growth in order to preserve the unique environment and character of the Vineyard.

Additionally, the Vineyard enjoys a half dozen conservation groups that work in tandem to preserve and protect the natural environment. Together with the commission and individual town committees, a concerted effort is underway to protect Vineyard sites of historical and ecological significance.

Each conservation group has a unique mission.

The Trustees of Reservations (TTOR), the oldest conservation organization in the country, originated with a letter from landscape architect Charles Eliot in 1890. Eliot proposed formation of this nonprofit conservation group to preserve parks in urban areas. He sought to protect "special bits of scenery." The purpose behind TTOR was that "lovers of nature will rally to endow the Trustees with the care of their favorite scenes, precisely as the lovers of Art have so liberally endowed the Art Museums." Legislation was approved in 1891, and the trustees have flourished ever since.

TTOR owns several properties on Martha's Vineyard, dedicated to its goal of preserving open space. It manages the property of Long Point, across from the airport. On Chappaquiddick, TTOR offers guided vehicle tours along Cape Pogue to the most remote Vineyard lighthouse. Kayak and canoe paddle trips are available. Walks are led through unspoiled maritime forests. And for the underage, "our enthusiastic guides will take you in an over sand vehicle to favorite spots in a quest for crabs, shellfish, minnows and more!"

The Martha's Vineyard Garden Club was established in 1924, the first Vineyard conservation group on the island. Members "share a passion for gardening, conservation, and maintaining our unique environment."

More than a quarter century later, in 1951, the Nature Conservancy was created to "protect ecologically important lands and waters for nature and people." The conservancy boasts more than one million members worldwide and combats environmental threats from climate change to water pollution.

The Nature Conservancy (TNC) seeks to diffuse the harmful effects of habitat fragmentation. Program manager Brian Lawlor explained, "The island has all this wonderful globally rare and significant habitat, but it has been carved up by roads and development." And "the risk for extinction gets higher and higher." TNC states that the island's ecosystem is all interconnected. "The Nature Conservancy wants to encourage Islanders to think of their own land as a link in the island-wide chain and take responsibility for stewardship of their property, no matter where they are situated."[125]

The Nature Conservancy website advocates that "small changes in how properties are managed can enhance populations of desirable wildlife,

reduce the strain on our ponds and bays, offer new resources to migratory species and turn barriers into bridges for wildlife seeking to move around Martha's Vineyard."

In 1959, *Vineyard Gazette* editor Henry Beetle Hough and his wife, Betty, lived in downtown Edgartown by Sheriff's Meadow, adjacent to an ice pond. To stave off impending development of the meadow and encroachment of the pond, the Houghs bought the property. Sheriff's Meadow was born.

Today, Sheriff's Meadow Foundation conserves more than two thousand Vineyard acres, with additional conservation restrictions: "The Foundation's properties represent all of the major Martha's Vineyard habitats: beaches, sand dunes, coastal ponds, wooded moraine, forests, swamps, marshes, agricultural lands, meadows and more."[126] Cedar Tree Neck off Indian Hill Road in West Tisbury is its most popular property. The organization preserves the natural landscape for future generations.

"Felix Neck Wildlife Sanctuary is a place for everyone, protecting the habitats, wildlife, and spectacular views for which Martha's Vineyard is renowned." With nearly two hundred acres and trails that pass through a salt marsh, woodlands, meadows and along the shore of Sengekontacket, Felix Neck offers something for everyone. Wildlife preservation abounds, from bird and butterfly gardens to natural observation points. Kayak tours are offered beneath the full moon.

The land was donated to the Massachusetts Audubon Society in 1968. The Audubon Society itself was founded in 1896 by two women, who, according to the Audubon website, "persuaded ladies of fashion to forgo the cruelly harvested plumage that adorned their hats." The site was named Felix Neck Sanctuary in honor of Felix Kuttashamaquat, a Wampanoag who lived on the peninsula, or neck, in the 1600s.

The first director of Felix Neck Sanctuary was Gus BenDavid. In 2006, he was succeeded by Suzan Bellincampi, who recently wrote *Martha's Vineyard: A Field Guide to Island Nature*, with data on edible Vineyard plants.

The sanctuary promotes Fern & Feather Summer Day Camp, where children savor the wonders of nature. "It's a camp where children spend their time exploring the marshes, the ponds, the forests, the saltwater and more."[127]

The Vineyard Conservation Society (VCS), founded in 1965, promotes a mission of advocacy, education and protection of natural resources. Through environmental stewardship, VCS seeks environmentally sound alternatives to the challenges of so-called progress. VCS has advocated for varied environmental sites from the Native Earth Teaching Farm to Waskosim's Rock and against development of the Southern Woodlands golf

course and a subdivision in Katama. "We partner with government and civic groups whenever possible to promote community action in defense of a viable Vineyard environment and future."[128]

In 1986, the Martha's Vineyard Land Bank was formed to protect Vineyard land. Today, more than three thousand acres on some sixty sites are preserved. Although this is less than 5 percent of the Vineyard's open land, it is a significant effort to protect the natural environment. Revenue for land purchase is generated by a surcharge of 2 percent on real estate transactions across the island.

"Balance is key in land bank property management," reports the Martha's Vineyard Land Bank, which stresses protection of the environment on its website. "The land bank is a rare breed. Neither a sanctuary program nor a park system, it is a middle ground where the highest virtues of conservation can be realized: public enjoyment of nature, where limits and restraint secure the natural world's future and prosperity."

Land bank properties are open to the public, year round, except during hunting season. Off-season walks are conducted. On the first Saturday in June, National Trails Day, the land bank organizes a cross-island hike from shore to shore. The hike ranges from fifteen to twenty miles and is open to anyone willing to put his or her feet to the ground. It is a unique opportunity to see how the land bank properties connect with one another and with private landholdings.

Polly Hill Arboretum, on State Road in West Tisbury, is an organization where plant conservation is key. Polly Hill herself began planting seedlings at her West Tisbury farmstead in the 1950s and kept at it until she died at age 101 in 2007. With over two thousand plants, bushes and trees on its property, the arboretum is a wonder of environmental education and conservation.

In addition to these conservation organizations, the Martha's Vineyard Preservation Trust has a mission to protect structures of historical significance. It currently oversees eighteen historic properties, ranging from Alley's Store and the Grange Hall in West Tisbury to the Flying Horses in Oak Bluffs. "Since 1975 the Martha's Vineyard Preservation Trust has acquired, preserved and managed the endangered landmarks of Martha's Vineyard, restoring living institutions to their rightful place in Island life."[129] The trust is a private organization, housed in the Dr. Daniel Fisher House in Edgartown. Through member contributions, historically significant Vineyard properties are preserved.

While not protected by the preservation trust, the Vineyard Playhouse falls into the category of historic structures worthy of respect. Renovations

on the Vineyard Playhouse began in 2011, with a $5 million campaign to rebuild the hundred-year-old structure and dedicate the Patricia Neal Stage. Patricia Neal was a strong advocate for the playhouse. When she passed away in 2010, it was decided to name the stage in her honor.

Bill Eville writes, "As the years pass, it is easy to forget just how big a star she was, especially as she became a familiar figure about the Island, enjoying meals at the Main Street Diner in Edgartown and attending shows at the Playhouse."[130] The *Gazette* article continues, "On screen Ms. Neal could shift in an instant from a huge radiant smile to disappointment or disdain, her wide-open face registering every emotion so acutely. She made men fall in love with her and fear her, all in the same moment."

Another structure, also not covered by the preservation trust, is the Gay Head Lighthouse, which must be moved back from the eroding cliffs. Politicians and engineers work hand in glove to accomplish this task. In 2014, the lighthouse was less than fifty feet from the receding cliffs. Could it be moved?

Permission had to be obtained from national and local governing bodies and abutting homeowners. Land was secured. Money was required. (In the autumn of 2014, Dana Gaines paddled his kayak fifty-two miles around the Vineyard and raised thousands of dollars toward the move.)

Actually, moving a lighthouse is relatively easy because of its low center of gravity.[131] It must be jacked up onto steel rollers, which move across steel beams. "The progress will be virtually imperceptible, just a few inches at a time."[132] The new site of the lighthouse will be close enough to maintain the sense of history but safe enough so that the structure will be preserved. During the move, perhaps a sign should be posted: "Lighthouse Crossing."

———

While the population of the Vineyard expanded in the 1970s, it exploded in the late 1980s and 1990s as a new wave of immigrants discovered the island. People from Brazil relocated to Martha's Vineyard in great numbers as their home country struggled economically. A majority of the immigrants were women, many from middle-class backgrounds.

A British reporter observed that Brazilians "now form the core of the island's labour force, tending the rich man's garden, cleaning his home and cooking his food. They work immensely hard, often sending most of their money home to their families." While Brazilians came to the island at the

height of economic prosperity, "like other islanders, many have to juggle a string of jobs off-season to stay afloat."[133]

An estimated three thousand Brazilians now live on Martha's Vineyard, and not all are legal citizens. The issue of undocumented residents irks some islanders, although the majority of Vineyarders "can trace [their ancestry] to people who immigrated to this country in search of a better life—many of whom faced opposition and strife for their part in taking jobs and opportunities away from those who immigrated before them."[134] Previous populations have immigrated and gradually assimilated into the melting pot of Martha's Vineyard, made up of Native Americans, African Americans and people from the Azores and Cape Verde.

Grocery stores, boutiques, sports teams and festivals are part of the cultural fabric Brazilians have woven into the Vineyard quilt. Eight Brazilian churches flourish on-island. Like their Portuguese-speaking predecessors from a century ago, Brazilians contribute a positive impact with their imported traditions.

Vineyard Haven (3.6 percent) and Edgartown (2.7 percent) are among American communities with the highest percentage of the population claiming Brazilian descent, based on United States census figures. (Such statistics are dubious, however, as Tisbury [2.1 percent] which *is* Vineyard Haven, is listed in the top twenty communities as well.)

A concerted effort is underway for Brazilians to integrate into American culture—to speak English, attain citizenship, comply with local laws. Yet like any immigrant culture, the importance of heritage and history of the homeland is paramount.

In an effort to promote representation of Brazilians in the island community, an organization was formed in 2011. The Brazilian Association of Martha's Vineyard (ABRAMAVIN) was designed to assist in citizenship issues, language programs, computer concerns and counseling.

"Since the Brazilian churches are a pivotal part of their lives, the group has been engaging those church leaders in conversations as to what and how they can work together toward shared goals of community development."[135] The organization seeks to promote public programs, which invite and include people across the spectrum of the Vineyard population.

Elio Silva, a successful Brazilian businessman, has lived and worked on the Vineyard since 1988. He said, "Many of those who have remained here have a greater stake in the community—their kids go to schools, they pay taxes, they're citizens." Like the people from England and Ireland, from Scandinavia, from Eastern Europe and the Azores, Brazilians are doing their best to make a life for themselves on Martha's Vineyard.[136]

HAIL TO THE CHIEFS

The president of the United States has visited Martha's Vineyard. More than once. President Grant set the tone during his visit in 1874; the excitement is palatable today when President Obama enjoys his annual Vineyard vacation. And over the years, other presidents have savored the tranquility of Martha's Vineyard—often, however, prior to actually serving in the Oval Office.

The earliest report of a pre-presidential visit was that of John Adams, who visited a college friend, Jonathan Allen, in Chilmark in 1760. Our second president was a mere twenty-four years old, and the United States was still a British colony. That exemplifies the role of the Vineyard among prospective presidents.

The *Vineyard Gazette* celebrated the arrival of President Grant in 1874: "Today has been a notable day in the history of Martha's Vineyard. For the first time in that history, a president of the Republic has landed on our shore, has partaken of our hospitality, has received in person the salutations of our people."[137] A visit from the chief executive was a big deal.

It was in the late summer of 1882 when President Chester Alan Arthur, sporting his magnificent sideburns, steamed into Menemsha Bight aboard the *Fish Hawk*. The Commission of Fish and Fisheries was assessing the decline of fish, and President Arthur participated in that investigation:

> *Though a passionate recreational fisherman—he is known to have vacationed at the famed Cuttyhunk Fishing Club for at least one week*

during his presidency—Arthur was in fact aboard the Fish Hawk *to watch the steamer trawl for such fish as herring, mackerel, and striped bass, whose dwindling numbers were a cause of rising national concern.*[138]

It is rumored that both Theodore Roosevelt and William Howard Taft also enjoyed the Cuttyhunk Fishing Club.

Massachusetts lieutenant governor Calvin Coolidge, before he was President Coolidge, visited the Vineyard several times—in 1915 for the Grand Illumination, in 1918 to acknowledge volunteers in Gay Head and again in 1929, when he hobnobbed with Gay Head lighthouse keeper Charles Vanderhoop.

It was during his 1918 tour that Coolidge and Governor Samuel McCall recognized that the town of Gay Head

had sent 17 men, or 10.4 percent of its population of 162, to serve in the Army and Navy—the largest percentage of any other city or town in New England. There was a pan-Island celebration—a parade in Vineyard Haven, a pageant in West Tisbury, refreshments in Edgartown, a dinner in Oak Bluffs—and at Gay Head, McCall dedicated a tablet that now rests in front of the town hall.[139]

"My father, Franklin D. Roosevelt Jr., summered on Martha's Vineyard for ten years beginning in 1966," wrote Laura Roosevelt, who moved to the Vineyard herself in 1995.

President Roosevelt, Laura Roosevelt's grandfather, never actually set foot on Vineyard soil but savored the waters off shore. He sought refuge from a storm by sailing his schooner into Katama Bay in 1933. In 1941, using his presidential yacht *Potomac* off Menemsha, he pulled off a deception of the press and public as he steamed off to Newfoundland while a lookalike aboard the *Potomac* motored through the Cape Cod Canal.

A month before Roosevelt's decoy mission, two bedraggled sailors blew ashore in Oak Bluffs, having undergone a rugged sail across Vineyard Sound. Joe Kennedy and his younger brother John were cared for at the Ocean View by the hotel's owner, Joseph Sylvia, and then sent on their way.

The Kennedy compound is in Hyannis, just across Vineyard Sound. The Kennedys frequently sailed to the Vineyard. As Mike Seccombe noted about President Kennedy: "He came here as a boy, as a young man, when he was a congressman and a senator. His family came, too, to sail, to swim, to water-ski, to hobnob and, on occasion, to attend church." Jackie water-

skied off Chappaquiddick in 1961; JFK stopped by the Edgartown Yacht Club in 1962 and 1963, shortly before his assassination. The Vineyard was a convenient destination for the Kennedys.

Many Kennedy tragedies relate to the Vineyard. Ted Kennedy drove his car off the Dike Bridge in 1969, which led to the death of Mary Jo Kopechne. The crash of John Jr.'s plane occurred off Gay Head, as he was about to land at the Martha's Vineyard Airport in 1999. That killed him; his wife, Carolyn Bessette; and Carolyn's sister Lauren. Mike Seccombe noted, "Their ashes were scattered on the waters off the island."

"Former President Richard M. Nixon was a traffic stopper on lower Main Street in Edgartown Saturday morning."[140] President Nixon, with his friend Bebe Rebozo, was met by Dan Flynn of the state police and chatted with Joe Sollitto, clerk of the superior court. "Nixon said simply that he had been watching the America's Cup races. 'That is, I'm supposed to be watching them, but I really don't understand it. I love the water, but it's watching it that I love.'"

The *Vineyard Gazette* article continued:

> *A little later in the morning, the former president and his party window-shopped briefly on lower Main Street in Edgartown, till he was stopped by between eighty and a hundred admirers, autograph-seekers, picture takers, and those who were just curious. Outside The Kafe (now, the Wharf Pub and Restaurant), he paused for photographs and more conversation, mainly with Island visitors.*

"'The Clintons are coming!' The rumor of early summer 1993 must have been true, because every Vineyarder down to the last pinkletink was within two degrees of separation from someone who really, really knew."[141] The story was indeed true, as the Clinton entourage landed at the Martha's Vineyard Airport on President Clinton's forty-seventh birthday, August 19, 1993.

Golf, coffee at Alley's, visiting the Hot Tin Roof, dining with the notables, enjoying ice cream and making himself visible and accessible were hallmarks of Clinton's presidential vacations on Martha's Vineyard. "Vineyarders long accustomed to honoring the privacy of celebrities in their midst may have been mystified, for here was a celeb bent on mingling."[142] Bill and Hillary even appeared with a local musical group, the Flying Elbows, at the Agricultural Fair.

"The Clintons returned to the Vineyard nearly every August of Bill's two terms in office, and they've returned nearly every year since. Perhaps the Clintons discovered, as others do, that Martha's Vineyard can be as much a healing place as a happy place."[143]

In one public event, Bill Clinton met Dean Denniston, an African American who grew up in Oak Bluffs, graduated from Boston University but was denied a teaching career due to racial discrimination. Denniston become a railroad pullman and met people as varied as Marilyn Monroe, Richard Nixon and Ted Williams. Dean Denniston was honored to sit with President Clinton at Union Chapel in Oak Bluffs.

"And so it came to pass that the Obamas—Barack, Michelle, and daughters Malia and Sasha—came here for a brief vacation" in 2004, when Barack was initially running for his Illinois Senate seat, years before he became President Obama. "He came and realized that it [Martha's Vineyard] had all the things that were perfect for him and the family: beaches, a lot of things for the children, and of course great golf courses."[144]

The Obamas came again in 2007 to vacation, play golf, read, work out, ride bikes and relax. Michelle's college roommate has a home in the campground. Valerie Jarrett, a close advisor to the president, often rents a home in Oak Bluffs. Professor Charles Ogletree, who taught both Michelle and Barack at Harvard, is a summer regular. Everyone on the island knew the president was here, but few saw him.

Each year of his presidency, except for the election year of 2012, President Obama vacationed on the Vineyard. He keeps a much lower profile than did President Clinton, but evidence of his presence is abundant, whether it is a night out at State Road Restaurant, a visit to Alley's General Store or his frequent golf outings.

And the job of the president continues, unabated, during vacation. President Obama has been called to respond to national and world events, to address political situations and to pursue his role as chief executive. Press conferences, secret service accompaniment and the demands of the office limit actual vacation time.

Vineyarders don't complain. They are flattered that this president, like so many before him, has chosen to spend time on our little piece of paradise.

First Lady Julia Grant accompanied her husband in 1874 on his whirlwind tour of the Vineyard.

Jacqueline Kennedy Onassis purchased property in Gay Head in 1978, some 350-plus acres off Moshup Trail. She rode her bike to the Gay Head Cliffs. She went to art exhibits, lectures and cocktail parties. She had an

osprey nest erected in support of the Felix Neck effort to boost the osprey population. And when she passed away in 1994, her children inherited the land. Daughter Caroline sought approval to subdivide the property, in 2006, so each of her three children can appreciate the land.

It is noteworthy that Jackie Kennedy, as an editor for Doubleday in the 1990s, encouraged Dorothy West, who participated in the Harlem Renaissance and was a resident of the Highlands in Oak Bluffs, to revise her manuscript on an interracial wedding. Together, the stately former first lady and the tiny, fiery, African American writer rewrote the story, which became *The Wedding*. Dorothy West dedicated the book to Jackie Kennedy. Oprah Winfrey produced the story in a Hallmark television special.

Lady Bird Johnson, widow of President Lyndon Baines Johnson, was a life-long environmentalist. For thirty years, she was a Vineyard Haven summer visitor, savoring the walks, the harbors and the laconic atmosphere of the Vineyard. In an interview with the *Vineyard Gazette*, she said, "I come across these lovely little dappled meadows of Queen Anne's lace and a good deal of black-eyed Susans and chickory. Chickory everywhere! Not as much butterfly weed as I'd like to see—it just sparkles with its brilliant color—and some fuzzy purple things, I don't know what they are."

"I just have a great affection for this place," she told the *Vineyard Gazette*. "I come here with a mindset of leaving all my cares at home."

In his eulogy in 2007, former LBJ aide Harry Middleton remembered Lady Bird's summers differently: "Each night was the occasion for at least two—sometimes three—festive events. One evening, halfway through the week, as we sped from a cocktail party to a dinner, she said: 'I don't know why I am doing this.'" Sometimes the allure of one more cocktail party fades in the shadows of a quiet walk along the beach.

A 1985 year-end summary of news in the *Vineyard Gazette* reported, "First lady Nancy Reagan made a very hush-hush—that is, highly public—stop at the West Tisbury summer home of Katharine Graham, chairman of the *Washington Post* Co. board."[145]

Hillary Clinton has visited the Vineyard. She came during her husband's presidency and since, promoting her senatorial campaign, her presidential campaign and her memoir. She draws enthusiastic crowds and makes a point of speaking to individuals as much and as often as she can.

Whether it's a high-profile visit with secret service attendants, a pre-presidential visit or simply a sail, Martha's Vineyard has garnered the interest of those in the Oval Office. It may be the bucolic country roads, the clear ocean views, the laid-back atmosphere or the sense that on

Martha's Vineyard one may relax and leave the troubles and concerns of the presidency behind. Whatever the reason, the Vineyard is proud to serve as a vacation site for presidents.

There's nothing wrong with sharing a little piece of paradise, especially on a PVD (perfect Vineyard day).

In checking the population of Martha's Vineyard, we find that Dukes County grew at a rate of 10 percent from 2000 to 2010, down from the 29 percent growth in the 1990s, yet it's still the highest growth rate of any Massachusetts community. The population of Dukes County in 2010 was listed as 16,535, but we know those figures are incomplete, as there are at least 3,500 Brazilians on the Vineyard, and many were unwilling to be counted in the census due to their immigration status. The median age of people in Dukes County is forty-five; the median age of Brazilians is thirty-one, making them more viable employees.

Dukes County is hardly the melting pot we'd like to think it is based on national statistics:

> *Given the Vineyard's long, proud reputation as a racially-tolerant place, it has a remarkably small black component. Only 3.1 per cent identified as black or African American, rising to 4.8 per cent when mixed race was included. This of course does not include the large, seasonal influx of the black middle-class.*[146]

The *Vineyard Gazette* summarized results of the national census in 2011:

> *So if you had to sum up the salient demographic features of the Vineyard at the start of the second decade of the 21st century, it would be something like this: old and getting older, very white but getting less so, expensive but not affluent, playground of the rich but home to the educated battler, and dependent for much of its labor and remnant youthful vigor on a group of people who we can't even count.*[147]

THE TWENTY-FIRST CENTURY

The Wampanoag tribe opened a heritage exhibit in Gay Head atop the cliffs in 2014. Designed as a *wetu*, or domed hut, it displays historic, cultural and present-day tribal programs. Bettina Washington, tribal historic preservation officer, said, "This building has important elements of our culture. What the Wampanoag are, how we got here and how we're still here and what we're doing." A skylight mimics the smoke hole in a wetu. This heritage exhibit is an educational opportunity to share the history of the Wampanoag with the multitude of visitors to the cliffs. Cultural elements are described, such as the belief that the world was created on the back of a turtle.

The Agricultural Fair began in 1858. For more than a century, it was held at the old Grange Hall in downtown West Tisbury. Over the years, the fair continued to expand, and by 1995, it had outgrown the four-acre site.

An old Vermont barn was taken down and rebuilt on a spacious site off Panhandle Road in West Tisbury. The barn raising took place in November 1994. It was followed by a musical fundraiser, highlighted by James Taylor and Carly Simon, to raise money for the barn roof.

Carpenters raced to prepare the hall for opening day of the fair. Fair employees worked into the wee hours to ready the site for exhibitors and patrons, recalled Kathy Lobb. The old stage was transplanted from the

Grange Hall so musicians had a familiar place to play. And when the fair finally opened in August 1995, fair manager Eleanor Neubert recalled, "it was a dust bowl, not a blade of grass on the property. It was very dusty; the wind howled." However, the Agricultural Fair had found itself a comfortable new home.

Portable pens were rented from the Barnstable Fairgrounds to house Vineyard ruminants. An animal barn was built in 1998; Amish builders constructed a second barn in 2008. The weather vane on the Ag Hall is a statuesque bovine, blowing with the wind.

While dust was overwhelming in 1995, water proved critical in the next two years. Drinking water was unsafe in 1996, so free bottled water was trucked in. The following year, the rains came, flooding the buildings and grounds. Pat Waring reported, "The rain collected in a huge puddle on Panhandle Road, and someone had put a little rowboat in it as a joke."[148]

Her article continued:

> Weather was so bad that Thursday's Fair was cancelled. M.V. Agricultural Society president Arnie Fischer Jr. and others went to West Tisbury selectmen with an emergency request to operate Sunday; the Sunday opening proved widely popular. Soon a request was filed with selectmen and approved to institute a four-day Fair.

A women's skillet toss began in 1998 and proved entertaining. The 150th anniversary was celebrated in 2011 with a parade of antique autos and farm machinery.

Still in charge of the fair, Eleanor Neubert observes that many things have changed over the years: "Nothing was cast in stone. And it still isn't: we still make minor changes every year."[149]

The wetu exhibit in Aquinnah and the Agricultural Hall in West Tisbury are worthy sights. All across the island are landscapes, memorable for their scenic beauty or unique aspect that add perspective to the Vineyard allure.

The public beach in Menemsha is popular: "The beach is crowded and very rocky so it is not the ideal swim. But a pair of fish stores, each with its loyalists, back up to the dock, where ships unload their daily catch. The sunset equals the nightly ritual at Key West, as natural and human spectacle."[150]

The bluffs along East Chop Drive, in Oak Bluffs, are worthy of exploration: "The crumbling corniche that wraps around East Chop bluffs and overlooks Nantucket Sound has a history of erosion-related closures."[151] In the 1950s, Donald Billings drove trucks onto the Bluffs to drop stone to shore up the cliff. It was closed for two years after Hurricane Bob in 1991, and the seaward lane closed after Superstorm Sandy. "Winter storm Nemo caused damage that closed the road entirely for two weeks."[152] The view from the Bluffs is worth taking in, whether walking or biking, as automobile traffic is restricted due to erosion.

Ancient ways are pathways where people and animals used to walk before automobiles dominated transportation. Ancient ways keep history alive: "Protecting these old roads (ancient ways) does much to retain the character of the Island, just as preserving historic buildings, retaining engaging vistas or saving unique parcels of land from development."[153]

Even as political preservation efforts are underway, parts of the island are slip-sliding away. Erosion raises serious questions of concern.[154] Along the South Shore, the movement of sediment is reshaping the perimeter of the

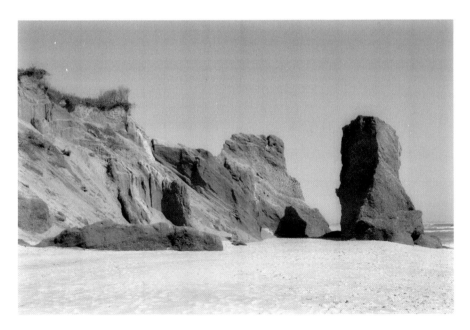

Tom Dunlop described the concerns of coastal homeowners: "People living on the cliffs, especially along the southern coastline, realize that the era of retreat has arrived." Houses have to be moved back from the coast along the seventeen-mile shoreline between Squibnocket and Chappaquiddick. The erosion along Lucy Vincent Beach is quite evident. *Photo by Joyce Dresser.*

Vineyard: "Wind and waves create a current and move much of the sand in a sawtoothed pattern down the coastline."[155] The shoreline is shifting as the ocean eats away at land along the south shore.

> *We know from the historic erosion rates, there's a foot to a foot-and-a-half* [of retreat per year] *on the Gay Head side; by Chilmark Pond is 2.5 to 3 feet; Tisbury Great Pond it's 4 to 5 feet and Edgartown Great Pond it's 6 or 7 feet and 10–12 feet at South Beach, because it's the finer part of the outwash plain.*[156]

Historically, the sea level has risen one foot every one hundred years: "Beginning about 125 years ago, the rate suddenly surged again to a bit more than a foot per century."[157] The Martha's Vineyard Commission believes, according to *Vineyard Gazette* reporter Olivia Hull, that "the level of the ocean around the Island could rise one and a half feet by 2050 and five feet by 2100, surpassing estimates for some other parts of the world." Christine Seidel, commission cartographer, devised a map of potential sea level rise. Down-island towns face a serious challenge with this higher level of ocean water. Most developed land will be threatened by the ocean's rise.

Martha's Vineyard basks in the shadow of presidential visits. It is a tourist mecca, a destination-wedding site, a place where the rich and famous build trophy homes—McMansions—yet live life without the mobs and hoopla of celebrities.

Beyond the rich and famous, besides the summer people, vacationers, tourists and day-trippers, Vineyarders relish the physical landscape of the island and treasure its history. One historical anomaly is the competitive attitude that has been evident for ages between Nantucket and Martha's Vineyard. The two islands off the south shore of Cape Cod are very different—historically, geographically and intrinsically. In relation to Nantucket, Martha's Vineyard is twice the size, twice the population and half the distance from Cape Cod. And Vineyarders like to think they have the better football team.

In 1950, Eleanor Roosevelt visited Martha's Vineyard and Nantucket and offered a rueful observation in her "My Day" newspaper column: "The rivalry between these two islands seems fairly vigorous, so I will only say that I found both of them delightful."

Gale Huntington, Vineyard historian, was less charitable, sharing a tale from Moshup, the legendary Wampanoag progenitor: "One day Moshop was smoking his pipe while fishing in the shoal water east of Chappaquiddick. The pipe went out, and he knocked the dottle [unburned tobacco] and ashes into the water in a little heap. That little heap is Nantucket."[158]

Nantucket and Martha's Vineyard have competed for generations. The Native American tribes distrusted each other. Whaling expeditions competed between the islands. The Vineyard was settled by Congregationalists and, later, Baptists and Methodists. Nantucket enjoyed a fervent Quaker community.

The competitive spirit is very much alive on the gridiron. Football is key to the sports programs on both islands. James Sullivan speaks to the isolated communities, "still very much provincial places. Everyone knew your business, and you knew theirs. It was, in fact, one of the key reasons that football had become such an institution on both islands. Social structure was paramount."[159] It was natural for high school football to flourish on Nantucket and the Vineyard and for the rivalry to evolve.

This legendary sports competition has been hard fought since the first game in 1960, when the Martha's Vineyard Regional High School fielded its first team. It was coached by Daniel McCarthy, for whom the Vineyard field is named. (Earlier, in 1953 and 1954, coach Jack Kelley had assembled a team with players from the three Vineyard high schools of Tisbury, Oak Bluffs and Edgartown.)

The Island Cup was inaugurated in 1978 by John Bacheller. He solidified the competition between the islands with a token representing victory. In the early years, the Nantucket Whalers, led by coach Vito Capizzo, repeatedly captured the Island Cup.

The Nantucket team was smaller but more aggressive. Vineyard announcer Ken Goldberg says of Nantucket, "Fathers play, uncles play, grandfathers play. Nantucket football is a big deal, culminated by the rivalry between the Vineyard and Nantucket. Years ago it didn't matter who Nantucket was playing, they just got so excited about it." Hundreds of fans attend Nantucket football games.

Announcer Goldberg captured the essence of the 1977 Vineyard-Nantucket game: "On a day filled with the winds of a Vineyard victory, Mark McCarthy took the handoff and swept around the end for 20 yards." Goldberg's graphic coverage claimed, "The Nantucket QB became a human sandwich between slices of hard hitting defenders and David Morris recovered a fumble." And "Nantucket did not reckon with Matt Ferro, who in addition to gaining 90 yards on offense, played a strong defensive game."[160]

By the mid-1980s, "the Island Cup game had reached near-mythical proportions."[161] It was said that on Nantucket, one thousand people

gathered to watch the rivalry—and three times that when the Whalers visited the Vineyard. Bob Tankard coached for eight years and won the Island Cup once through 1987.

When Donald Herman became the Vineyard coach, he gained the upper hand on Capizzo's Whalers with a stronger, faster Vineyard team, sparked by improved training and playing skills.

Ken Goldberg has been involved with sports reporting since the late 1970s: "I was scorekeeper, time keeper and wrote for the *Cape Cod Times*. I just did it all." He started announcing football games when the Island Cup regime began in 1978. "I called up one day and they said I could do it. I've seen every championship game of every sport on the Vineyard," he says. "Hockey, football, basketball champions."

Ken Goldberg "has a knack for bestowing catchy nicknames," says author (*Island Cup*) James Sullivan. A favorite phrase is "the coss of the toin."

He recalls key moments of the most memorable games. In the 1985 match-up, "Eric Blake picks up a fumble and runs it back some 40 yards to give Martha's Vineyard a 12-2 win." (Eric Blake is Oak Bluffs' current police chief.) In 1992, with less than five minutes to play, quarterback Jason Dyer threw touchdowns to Albie Robinson and Keith Devine for victory.

Goldberg recalls 2004, with the water-boy fiasco: "E.J. Sylvia kicks a field goal with 4 seconds left to give MV 21-20 lead. Kickoff return ends with Water Boy Maseda getting in the way, knocked him down, lateraled the ball. They have to go around him. You can't make this stuff up."

The seventeen-minute drive in 2011 was memorable when the winning score occurred as "the clock forgets to stop." And in 2012, with only 4:41 on the clock, Alex Tattersall threw two touchdowns, one to Go Go Watkins and another to Joe Turney for a Vineyard victory. As Goldberg says, "There's always something about Nantucket."

The year following Vito Capizzo's retirement in 2009, there was no Island Cup. Mixed messages created a scheduling snafu, and no one competed for the cup.

Coaches put the game in perspective. Neither coach Don Herman nor coach Vito Capizzo said this, but either could have: "Winning breeds happiness. But it's more than that. I think what we've accomplished here is sort of a testament, not to me…but it's the kid who played, it's the families who were a part of this town. Everyone's had a hand in this."[162]

Today, the Island Cup is an exciting example of the island rivalry between Martha's Vineyard and Nantucket. (In 2014, the Vineyard defeated Nantucket 21–7 at home, taking the lead in games won, 19– 17.)

EPILOGUE

Life on the Vineyard goes on, even as the older generation—the greatest generation—passes on.

Bud Mayhew "was a happy presence in almost all gatherings of the town," wrote Jane Slater[163] on the death of Elmore "Bud" Mayhew in the autumn of 2014. She and Bud were classmates at the Menemsha School, "sharing all sorts of adventures open to Chilmark young through the war years." Bud Mayhew "never met a person he didn't like, and he managed to keep in touch with people all over the world whom he met along the way." Jane Slater speaks to those who knew him when she writes, "We will all miss his cheerful and happy presence and the opportunity to swap one more story of our mutual past, a pleasure we never tired of."

Just a few weeks later, Jane Slater's husband, Herb, passed away. He was eighty-seven and a fixture in the Menemsha community. Once more, family and friend, the town and the island mourned the death of a stalwart, caring, vibrant Vineyarder. Life moves on, but the memories of those who passed before linger.

The history of Martha's Vineyard is the history of a tightknit community. It is the history of the United States in miniature. It is the story of people and places, working together, affected by the outside world but most involved with family, friends, neighbors and their island community home.

A TOUR OF
MARTHA'S VINEYARD

When you visit Martha's Vineyard, the ferry usually docks in Vineyard Haven. From there, you can drive counterclockwise around the island, over the main roads, with side ventures or options available (noted here). This is one of the best ways to learn the history of Martha's Vineyard.

It is too far to walk. Some people like to bike, but to circumnavigate the island on land is more than fifty miles. Hence, we suggest taking a sightseeing bus or van, which caters to the day-tripper who wants to see (and hear) the highlights of Martha's Vineyard.

A more personalized, individual tour can be taken by car, driving yourself, following a few simple directions. Keep your eye out for scenic vistas, historic structures and the inevitable moped or bike plodding along the edge of the roadway or turkeys crossing the road, single file.

Start in Vineyard Haven, at the Steamship Authority building. From the parking lot, turn left toward Five Corners, the busiest intersection on the Vineyard. (No traffic light, no policeman and few stops signs.) Watch for oncoming trucks, buses, cars, motorcycles, bicycles and, especially, pedestrians dashing across the roadway, hurrying for the ferry. Turn right and head up the slight hill.

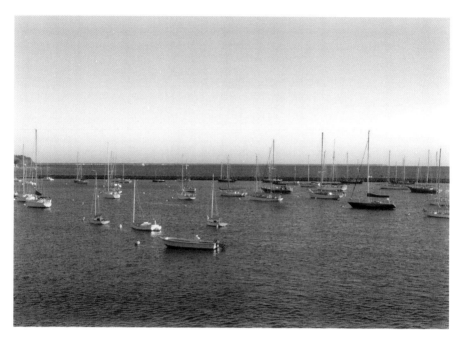

Vineyard Haven Harbor is the commercial center of the Vineyard, with year-round ferry service, barges delivering fuel oil and gasoline, pleasure boats and various other craft. *Photo by Joyce Dresser.*

OPTION #1

Take your first right and drive slowly down Main Street, past the Mansion House, a historic hotel that anchors local businesses. Continue along Main Street, past retail shops, restaurants, Bunch of Grapes Bookstore and then on and up past Owen Park and the Vineyard Haven Library. Continue out and around West Chop, passing the scenic Sheriff's Meadow preserve that overlooks the harbor, on to the West Chop lighthouse and beyond to the West Chop Beach Club and overlook. Mink Meadows and a mid-Chop walk are memorable on the return trip down Franklin Street. Turn right on Center Street and follow it out to State Road, by the Black Dog Café and the Tashmoo Overlook.

Driving through Vineyard Haven, you sense the bustling community that once harbored dozens of sailing ships, as well as crew and supplies of the nautical trade. Vineyard Haven was a primary port of call on the route between New York and Boston prior to the construction of the Cape Cod Canal in 1914.

Landmarks in town include the ferry slip, the Black Dog tavern, the Black Dog Café with the Boston & Maine train car on State Road and the Tashmoo Overlook. At the overlook, look out across Lake Tashmoo, with a little strip of land by the ocean's edge; then Vineyard Sound; and finally the mainland beyond. (We call that mainland in the distance "America.")

Just beyond the scenic overlook is a road going off to the right: Lower Lambert's Cove.

OPTION #2

Take this bucolic roadway, which loops by a cranberry bog and Duarte's Pond. Stop for a stroll on Lambert's Cove Beach, with a woodsy walk to the ocean. Pass the road to Lambert's Cove Inn, followed by a trio of kettle ponds, Uncle Seth's Pond and then back up to State Road.

Follow State Road into West Tisbury; stay on State Road for most of the first half of this adventure.

OPTION #3

Try Indian Hill Road, which angles off to the right immediately after the junction of Upper Lambert's Cove Road. At the first intersection, turn right toward Christiantown, where you discover a secluded chapel, a land bank property and a Native American graveyard. Back on Indian Hill Road, this roadway stretches up two miles, past horse farms, fields and forests, dead-ending at the top of Indian Hill, where a turnaround offers a ready return to State Road.

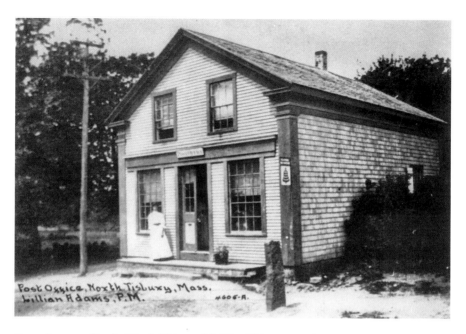

Once the post office for North Tisbury, this West Tisbury store has seen iterations as the Red Cat Bookstore; today, it is the clothing shop Bananas. *From the collection of Connie Sanborn.*

Continue along State Road into North Tisbury, with Middletown Nursery, the Glass Works and State Road Restaurant. Veer left over the Mill Stream and pass the Polly Hill Arboretum, followed by the Agricultural Society Hall, with a weather vane of a cow, on the right. Ahead is the West Tisbury town cemetery, located at Dead Man's Curve, where Nancy Luce is buried. When you reach the West Tisbury town center, Alley's General Store is to the right, and the Field Gallery is to the left. West Tisbury is the agricultural hub of the island. The quaint town center has a little Congregational church, the town hall and Grange Hall.

Continue through town, crossing the tiny Tiasquam River, headed for Chilmark, the heart of sheep country. After a ride up and over Abel's Hill Cemetery, where a split-rail fence designates John Belushi's grave, pass wooded fields bordered by the ever-present stone wall. Note the Allen Sheep Farm, with a view of sheep to the right and the south shore to the left. Lucy Vincent Beach is tucked in along the shoreline. Continue on to Beetlebung Corner, the busiest intersection up-island.

OPTION #4

A highly recommended option is to take a side trip to Menemsha, journeying right down Menemsha Crossroads. Return to State Road and continue on to Aquinnah.

Follow signs to Dutcher Dock in Menemsha, a picturesque fishing community featuring Squid Row. Tourists and locals flock to the shores of Menemsha, lobster rolls in hand. When the sun sets, they pause to clap and then return to their delectable delights. *Photo by Joyce Dresser.*

From Beetlebung Corner, continue toward Aquinnah. Pass, on the right, the Chilmark Store, Chilmark Tavern and the Chilmark Police Station, a former two-room schoolhouse. The new Chilmark School is on the left. Continue up State Road, passing Chilmark Chocolates (do stop if they are open!), and then dip across Stonewall Pond, with Nashaquitsa Pond to your right. Just up the road, on the left, is an ancient sheep pound.

Carry on to Aquinnah, formerly Gay Head. Two great stone markers on the left signal the Wampanoag Tribal Headquarters. Continue on State Road, heading for the cliffs.

OPTION #5

Take a right at Lobsterville Road, heading out to West Basin for a great view of Menemsha and the Elizabeth Islands. On the return, go right onto Lighthouse Road and wend your way out to the cliffs.

As you pass through town, slow down. A former schoolhouse, now a library, is on the left; town office buildings, along with police and fire departments, are on the right. Ahead await the cliffs and the lighthouse. To the left are Moshup Trail and Moshup Beach. Moshup Trail wanders along the shore, with a windswept view of the ocean, eroding sand dunes and low-growth vegetation. Moshup Beach rests below the cliffs.

Take the loop of Moshup Trail, which brings you back to State Road. Head down the hill and stop briefly at the overlook for a view of Menemsha Pond and Menemsha. Continue to Beetlebung Corner. Pause at the stop sign beside the Chilmark Library.

To retrace your steps down-island, turn right along State Road to West Tisbury.

OPTION #6

Turn left along Menemsha Crossroads. Take a right at the end, going down-island via North Road. Flanders Field is on your

right with a windmill. Continue past Menemsha Hills, with its long, leisurely stroll to the highland shore. Farther along, Great Rock Bite also presents ocean access. Pass Tea Lane, Wascosim's Rock and Seven Gates to make this venture complete, ending on State Road in the shadow of the great oak tree.

Option #7

From Beetlebung Corner, cross directly down Middle Road, which ambles peacefully uphill and down, past wooded lands and open fields and eventually feeds into West Tisbury. Enjoy the land bank properties of Fulling Mill Brook, Middle Line, Tea Lane and Tiasquam along the way. Go right at the end of the road onto Music Street into the town center. This is arguably the premier drive of the island. Re-enter West Tisbury, with the town hall to the right and the iconic Congregational church to the left.

Proceed through town, bearing right, toward Edgartown, slowly passing the old Mill Pond.

You are now leaving Upis Land, or up-island, as it may be referred to.

The route to Edgartown is straight but has a few dips from eons of glacial water runoff thousands of years ago. No one got around to leveling the roadway, so take the rises and falls with care and appreciate this bit of ancient history as you pass the airport.

On the approach to Edgartown, Morning Glory Farm is on the right. It is a superb farm stand, one of the island's premier agricultural establishments. It's a good place to stock up on fresh veggies. Continue on to Edgartown, county seat of Dukes County. Go through two stop signs and then turn right onto Main Street, with Cannonball Park on the left and the Dukes County House of Correction just ahead. (Notice the neat white clapboards and black shutters; also note the bars on the second-floor windows.)

Proceed down Main Street. On the left is the Dr. Daniel Fisher House. The weathered structure in back is the Vincent House, dating to 1672. Next is the 1840 Whaling Church, followed by the redbrick Dukes County Courthouse.

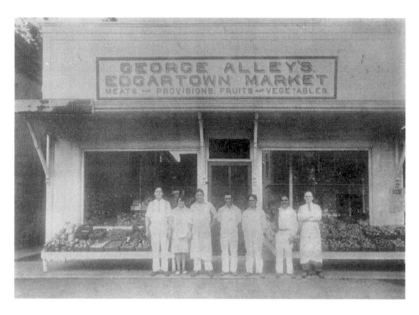

While Edgartown is the county seat, it retains the small-town atmosphere indicative of a community that prides itself on charm and harmony. Even a century ago, Edgartown was the premier township on the Vineyard. *From the collection of Connie Sanborn.*

Option #8

At the foot of Main Street is a parking lot on the harbor. Take a left to an observation deck that overlooks Chappaquiddick across the harbor. It's worth pausing to check out the views.

Option #9

Take the *On Time* ferry to Chappaquiddick. Several scenic conservation properties may be explored, and many scenic sights, but no businesses, shops or restaurants. A couple points of interest are the Community Center by Brines Pond and Wasque, operated by The Trustees of Reservation. Also, My Toi garden is a pleasant respite on the road to the Dike Bridge.

Continue down Main Street and turn left onto North Water Street, past the old Carnegie library and on to the Edgartown lighthouse, a short walk down from the Harbor View Hotel. (This is a secondhand lighthouse, as it came from Ipswich, Massachusetts, following the destruction of the old Edgartown light and keeper's cottage in the 1938 hurricane.)

Continue around Starbuck Neck, doubling down Fuller Street to Pease Point Way and passing white picket fences adorned with the requisite red, white or pink rose bushes. Pass the Vincent House and emerge on Main Street again.

OPTION #10

Drive to Katama. Proceed out of town, taking the left fork out to South Beach, heading along the shoreline and looping back up the right fork to Main Street. If you love a dramatic beach, South Beach offers the surf, the waves, the wind and the atmosphere.

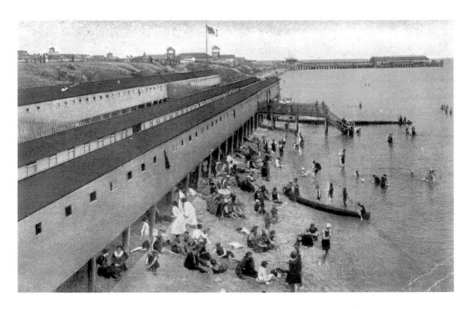

This postcard from Pay Beach, Oak Bluffs, shares the enthusiasm of the crowds, enjoying the beach. The expansive bathhouses are no longer extant. Nor is the Tivoli, in the background.

From downtown Edgartown, turn right onto Main Street and head for Oak Bluffs. Pass a number of businesses. Go right at the fork to head out along the shoreline. State Beach is a grand expanse, two and a half miles long, with plenty of sea, shore and parking and the pleasure of a peaceful environment. There are no amenities, however. Eventually, you come to Farm Neck Golf Course on the left and the cove of Harthaven on the right.

Next is Oak Bluffs, the party town—but with a religious counterpoint. Landmarks include Inkwell Beach, Villa Rosa, Ocean Park with its gazebo, the Civil War statue and the Flying Horses. Ride or walk up Circuit Avenue to absorb the flavor of this honky-tonk town. Stroll through the nineteenth-century Methodist campground with its myriad quaint gingerbread cottages.

From downtown Oak Bluffs, drive up New York Avenue toward Vineyard Haven.

OPTION #11

As New York Avenue turns sharply to the left, continue straight toward the ocean along East Chop Drive to appreciate the scenery along Crystal Lake, once an ice pond. Continue up the hill by the historic East Chop lighthouse, which was known as the chocolate lighthouse when it was painted brown in the 1980s. Continue back to New York Avenue, heading along the harbor, over the drawbridge and into Vineyard Haven.

As New York Avenue turns left, you will pass the state police barracks, the Martha's Vineyard Hospital and catch a view or two of Vineyard Haven Harbor as you cross the drawbridge over the Lagoon. Vineyard Haven lies ahead.

You've made the island loop!

NOTES

CHAPTER 1

1. Wampanoag.com.
2. Scoville, *Indian Legends*, 4.
3. Ibid.
4. Ibid., 9.
5. Dresser, *Wampanoag Tribe*, 23.
6. Scoville, *Indian Legends*, 19.
7. Ibid.
8. Ibid.

CHAPTER 2

9. Schlieff, "Gosnold."
10. Archer, *Gosnold's Settlement*, 3.
11. Dugan, *Ephemeral History*, 1.

CHAPTER 3

12. Danforth, *Island Tours*.
13. Mayhew, *Looking Back*, 143.

Chapter 4

14. Sydna Eldridge, as quoted by Connie Sanborn.
15. Banks, *History*, 412.
16. Ibid.
17. Ibid., 372.

Chapter 5

18. Norton, *Martha's Vineyard*, 23.
19. Ibid., 37.w
20. Waterway, *Gay Head Lighthouse*, 38.
21. Norton, *Martha's Vineyard*, 39.
22. Cornell, *Eighty Years Ashore*, 11–12.
23. Ibid., 126–27.
24. Ibid., 170.
25. Riggs, *Off Island*.
26. Girlonawhaleship.org.
27. Morris and Morin, *Island Steamers*, 5.
28. Ibid.

Chapter 6

29. Kageleiry, *Island That Spoke*, 4.
30. Ibid.
31. Groce, *Everyone Here*, 43.
32. Kageleiry, *Island That Spoke*, 1.
33. Ibid., 5.
34. Nora Groce, *Dukes County Intelligencer*, 92–4.
35. Groce, *Everyone Here*, 107.
36. Ibid.
37. Ibid., 61.
38. http://deafness.about.com/cs/featurearticles/a/marthasvineyard.htm.
39. Kageleiry, *Island That Spoke*, 7.
40. Gale Huntington, *Dukes County Intelligencer*, 95.
41. Ibid.
42. Kageleiry, *Island That Spoke*, 3.
43. Gale Huntington, *Dukes County Intelligencer*, 102.
44. Groce, *Everyone Here*, 108.
45. Kageleiry, *Island That Spoke*, 9.
46. Sydney Bender, *Vineyard Gazette*, October 24, 2014.

Chapter 7

47. Meras, *County Editor*, 52.
48. Norton, *Martha's Vineyard*, 48.
49. Ibid., 49.
50. Bill Milhomme, *Martha's Vineyard Times*, August 13, 2009.
51. Morris and Morin, *Island Steamers*, 18.
52. Ibid.
53. *Vineyard Gazette*, August 28, 1874.
54. Morris and Morin, *Island Steamers*, 26.
55. *Vineyard Gazette*, August 28, 1874.
56. Kageleiry, *Island That Spoke*, 8.

Chapter 8

57. That name change and the one from Gay Head to Aquinnah in 1998 were two of only three Massachusetts town name changes in the twentieth century. The third town, Manchester, added By-the-Sea, in 1989.
58. *Vineyard Gazette*, August 18, 1967.
59. Ibid.
60. Waterway, *Gay Head Lighthouse*, 58.
61. Norton, *Martha's Vineyard*, 74–5.
62. Ibid., 83.
63. Waterway, *Gay Head Lighthouse*, 80.
64. Leon Neyfakh, *Boston Globe*, December 21, 2014.
65. Nerney, *Reflections*, 3.
66. Dresser, *Women*, 62; see also Lee, *Vineyard Voices*, 118.
67. Dresser, *Women*, 108.
68. The Portuguese Genealogy Project website (http://history.vineyard. net/mvpgp/index.html) is dedicated to the history and genealogy of the Portuguese families of Martha's Vineyard, including immigrants from the Azores, the Cape Verde Islands and the Madeira Islands who settled on Martha's Vineyard.
69. Dresser, *Women*, 106.
70. Dresser and Muskin, *Music*, 35.
71. Ibid.
72. Norton, *Martha's Vineyard*, 61.
73. Ibid.

Chapter 9

74. Tom Dunlop, *Vineyard Gazette*, September 4, 2009.
75. Protective jetties were constructed around the harbor, and today it is an idyllic nest for vacationing boaters.

Chapter 10

76. Steamship Authority, *Lifeline*, 19.
77. Dresser, *Women*, 142.
78. *Vineyard Gazette*, September 27, 2013.
79. Cynthia Meisner, *Vineyard Gazette Chronicle*, June 3, 2010.
80. http://www.mwdc.org/Shipwrecks/JohnDwight.html.
81. Steamship Authority, *Lifeline*, 20.
82. Ibid., 26.
83. Ibid., 105.
84. Chris Baer, *Martha's Vineyard Times*, n.d.
85. Chris Baer, Vintage Vineyard Photos.
86. Tom Dunlop, *Vineyard Gazette*, August 22, 2014.

Chapter 11

87. A plaque was placed near where the last heath hen was seen.
88. Carolyn Johnson, *Boston Globe*, March 7, 2014.
89. Ivy Ash, *Gazette*, July 24, 2014.
90. Kristen Kingsbury Henshaw, *Martha's Vineyard Magazine* (September/October 2006).

Chapter 12

91. Steamship Authority, *Lifeline*, 26.

Chapter 13

92. *Boston Globe*, September 21, 2013.
93. Tom Dunlop, *Vineyard Gazette*, August 28, 2014.
94. Ibid.
95. Mayhew, *Looking Back*, 37.
96. Morris and Morin, *Island Steamers*, 136.
97. Tom Dunlop, *Vineyard Gazette*, September 12, 2014.
98. *Vineyard Gazette*, October 18, 2013.
99. Peter McGhee, *Vineyard Gazette*, November 28, 2014.
100. Ibid.
101. Steamship Authority, *Lifeline*, 30.
102. Ibid.
103. Morris and Morin, *Island Steamers*, 144.
104. Ibid.
105. Olive Tomlinson (as told to Linsey Lee), *Vineyard Gazette*, February 28, 2013.

CHAPTER 14

106. Tony Omer, *Martha's Vineyard Times*, August 29, 2013.

107. Sullivan, *Island Cup*, 124.

CHAPTER 15

108. Ivy Ashe, *Vineyard Gazette*, August 1, 2013.

109. Ibid.

110. Ibid.

111. Gottleib, Jaws *30ᵗʰ Anniversary*, 9.

112. Ibid., 150.

113. Ibid., 205.

114. Lee Fiero was interviewed on October 16, 2014.

115. *Vineyard Gazette*, October 21, 1977.

116. *Grapevine*, November 23, 1977.

117. Island Theatre Workshop website, http://itwmv.org/about-itw/history.

118. Ibid.

119. Mike Seccombe, *Martha's Vineyard Magazine* (September/October 2007).

120. Ibid.

121. Ibid.

122. Ibid.

123. *Martha's Vineyard Times*, December 15, 1978.

124. *School's Out*, 2013, 29.

CHAPTER 16

125. Gwyn McAllister, *Martha's Vineyard Times*, January 1, 2013.

126. www.sheriffsmeadow.org.

127. http://www.massaudubon.org/get-outdoors/wildlife-sanctuaries/felix-neck.

128. http://www.vineyardconservation.org.

129. http://www.mvpreservation.org/p.php/home.

130. Bill Eville, *Vineyard Gazette*, August 1, 2014.

131. Alex Elvin, *Vineyard Gazette*, August 14, 2014.

132. Ibid.

133. Tom Leonard, *Telegraph*, August 28, 2009, http://www.telegraph.co.uk.

134. Mathea Morais, *Martha's Vineyard Patch*, May 25, 2011.

135. Perry Garfinkel, *Martha's Vineyard Times*, May 18, 2011.

136. Ibid.

Chapter 17

137. *Vineyard Gazette*, August 20, 1874.
138. Tom Dunlop, *Martha's Vineyard Magazine* (August 2009).
139. Ibid.
140. *Vineyard Gazette*, September 16, 1980.
141. Shelley Christiansen, *Martha's Vineyard Magazine* (August 2009).
142. Ibid.
143. Shelley Christiansen, *Martha's Vineyard Magazine* (August 2009).
144. Lauren Martin, *Martha's Vineyard Magazine* (August 2009).
145. *Martha's Vineyard Magazine* (August 2009), posted online February 22, 2010.
146. Mike Seccombe, *Vineyard Gazette*, May 19, 2011.
147. Ibid.

Chapter 18

148. Pat Waring, *Martha's Vineyard Times*, August 21, 2014.
149. Ibid.
150. *New York Times*, August 10, 2014.
151. *Martha's Vineyard Times*, November 2, 2014.
152. Ibid.
153. Robert Green, Letter to the Editor, August 29, 2014.
154. Tom Dunlop, *Vineyard Gazette*, August 16, 2013.
155. Ibid.
156. Ibid.
157. Ibid.
158. Dresser, *Wampanoag Tribe*, 21.
159. Sullivan, *Island Cup*, 260.
160. Ken Goldberg, *Grapevine*, November 23, 1977.
161. Sullivan, *Island Cup*, 138.
162. Julian Benbow, *Boston Globe*, November 16, 2014.

Epilogue

163. Jane Slater, Chilmark correspondent of the *Vineyard Gazette*, November 14, 2014.

BIBLIOGRAPHY

Archer, Gabriel. *Gosnold's Settlement at Cuttyhunk*. Boston: Old South Work, 1902.

Banks, Charles. *The History of Martha's Vineyard, Dukes County, Massachusetts in Three Volumes*. Edgartown, MA. Reprint, Dukes County Historical Society, 1966.

Cornell, E.C. *Eighty Years Ashore and Afloat or the Thrilling Adventures of Uncle Jethro*. Boston: Andrew Graves, 1873.

Dagnall, Sally. *Martha's Vineyard Camp Meeting Association, 1835–1985*. Oak Bluffs, MA: Martha's Vineyard Camp Meeting Association, 1984.

Danforth, R.L. *Island Tours*. Vineyard Auto Line, Tivoli Building, n.d.

Dresser, Thomas. *African Americans on Martha's Vineyard*. Charleston, SC: The History Press, 2010.

———. *Disaster Off Martha's Vineyard*. Charleston, SC: The History Press, 2012.

———. *Mystery on the Vineyard*. Charleston, SC: The History Press, 2008.

———. *Tommy's Tour of the Vineyard*. Oak Bluffs, MA: DaRosa's Martha's Vineyard Printing Co., 2005.

———. *The Wampanoag Tribe on Martha's Vineyard*. Charleston, SC: The History Press, 2011.

———. *Women of Martha's Vineyard*. Charleston, SC: The History Press, 2013.

Dresser, Thomas, Herbert Foster and Jay Schofield. *Martha's Vineyard in World War II*. Charleston, SC: The History Press, 2014.

Dresser, Thomas, and Gerold Muskin. *Music on Martha's Vineyard*. Charleston, SC: The History Press, 2014.

Dugan, Holly. *The Ephemeral History of Perfume: Scent and Sense in Early Modern England*. Baltimore, MD: Johns Hopkins University Press, 2011.

Gottlieb, Carl. Jaws *30th Anniversary*. New York: Newmarket Press, 2005.

Groce, Nora. *Everyone Here Spoke Sign Language: Hereditary Deafness on Martha's Vineyard*. Cambridge, MA.: Harvard University Press, 1985.

Josephs, Peter Colt. *Remarkable Brick Barns of Martha's Vineyard*. Chilmark, MA: Brick Barn Press, 1974.

Kageleiry, James. *The Island That Spoke by Hand*. Trenton, GA: Silent Word Ministries, 1999.

Mayhew, Shirley. *Looking Back*. Tisbury, MA: Tisbury Printer, 2014.

Meras, Phyllis. *Country Editor Henry Beetle Hough and the* Vineyard Gazette. Bennington, VT: Images of the Past, 2006.

Morris, Paul, and Joseph Morin. *The Island Steamers*. Nantucket, MA: Nantucket Nautical Publishers, 1977.

Nernay, Ruth. *Reflections in Crystal Lake*. N.p.: self-published, 1985.

Norton, Henry. *Martha's Vineyard History Legends Stories*. Hartford, CT: Pyne Printery, 1923.

Page, Herman. *Rails Across Martha's Vineyard: Steam Narrow Gauge and Trolley Lines*. David City, NE: South Platte Press, 2009.

Railton, Arthur. *The History of Martha's Vineyard: How We Got to Where We Are*. Beverly, MA: Commonwealth Editions in Association with Martha's Vineyard Historical Society, 2006.

Riggs, Dionis Coffin. *From Off Island*. New York: McGraw-Hill, 1940.

Sanborn, Constance. *The Magic Sea Glass of West Chop*. Vineyard Haven, MA: Tisbury Printer, 1985.

Schlieff, Karle. "Gosnold: 1602." 1http://ancientlights.org/gosnold.html.

Scoville, Dorothy. *Indian Legends of Martha's Vineyard*. Oak Bluffs, MA: Martha's Vineyard Printing Company, 1970.

Steamship Authority. *Lifeline to the Islands*. Woods Hole, MA: Steamship Authority, 1977.

Sullivan, James. *Island Cup: Two Teams, Twelve Miles of Ocean and Fifty Years of Football Rivalry*. New York: Bloomsbury, 2012.

Waterway, William. *Gay Head Lighthouse: The First Light on Martha's Vineyard*. Charleston, SC: The History Press, 2014.

Weiss, Ellen. *City in the Woods: The Life and Design of an American Camp Meeting on Martha's Vineyard*. New York: Oxford University Press, 1987.

PERIODICALS

Boston Globe

Dukes County Intelligencer

Grapevine

London Telegraph

Martha's Vineyard Magazine

Martha's Vineyard Times

New York Times

School's Out

Vineyard Gazette

INDEX

A

Active (locomotive) 80, 83
Adams, Lucy and Sarah 51
Agricultural Fair 54, 143
Apollo (whale ship) 39
Aquinnah 17, 156

B

Bell, Alexander Graham 48
Brazil 135
brickyards 68
Burton, Randall 38

C

Camp Meeting Association 57, 79
Cape Verde 71
Chappaquiddick 31, 38, 119, 120, 158
Charles W. Morgan 93
Chilmark 121, 149, 154
Christiantown 31
Civil War 55
Clinton, Hillary 141
Clinton, President Bill 139
Concord 23
Coolidge, President Calvin 138
Cuttyhunk 25

D

deafness 47

E

Edgartown 30, 94, 157
Essex 43

F

Fierro, Lee 125, 127
Fisher, Dr. Daniel 40
Flying Horses 89

G

Gay Head 92, 107
Gosnold, Bartholomew 23
Grant, President Ulysses S. 61, 137
Grey's raid 37

H

Hardy, Will 89
heath hen 97, 98
Huntington, Gale 51
Hurricane Carol 108, 109
Hurricane of 1938 107

I

ice 69, 71
Indian Converts 29
Innisfail 74
invasion (World War II) 105
Island Cup 147

J

Jaws 123, 126

K

Katama 74
Kennedy, President John F. 138
Kennedy, Senator Ted 119, 131

L

Land Bank 134
Look, Harold 100
Luce, Nancy 51

M

Martha's Vineyard Airport 106
Martin, William 43
Mattakeesett 76, 82
Mayhew, Experience 29
Mayhew, Thomas 27, 28
McDonald, Ronald 130
Menemsha 104, 108, 109, 111, 155
Metacomet 30
Monohansett 60, 85
Moon Cusser 118
Moshup 17
Moshup Trail 116

N

Nantucket 147
New York 30
Nixon, President Richard 139
Noepe 17, 27
No Nukes Concert 123

O

Oak Bluffs 82, 118, 145, 160
Obama, President Barack 140
Onassis, Jacqueline Kennedy 140
Owen, Knight 100

P

Preservation Trust 134

R

Rambler 86
Rebecca (slave) 35
Roosevelt, President Franklin D. 104, 138
roque 92

S

sassafras 25
Saunders, John 37
secession 128
Seven Gates 71
Shearer, Charles 88
Shearer Summer Theatre 116
Sheriff's Meadow 133
Signal Corps 105
Smith, Clara 102

T

Taylor, Kate 119
Tivoli 88
Tracy, Harold 102, 103

V

Van Ryper Shop 105
Vineyard Gazette 54, 121, 128, 142
Vineyard Haven 72, 151

W

Wampanoag 17, 21, 27, 30, 64, 143
West Tisbury 143, 154
Wopanaak 28

ABOUT THE AUTHOR

When Tom Dresser was in the second grade, he could recite all the presidents of the United States in order. (Of course, he only had to go up to Eisenhower in those days.) By third grade, he could do it in reverse. Tom loved American history and biography. He claims he read a biography of John Quincy Adams eighteen times.

Tom graduated from college with a degree in American history and civilization and spent thirty years teaching and administering, often with a biography or historical novel at his side. At his thirtieth high school reunion, Tom re-met classmate Joyce Cournoyer, who invited him down to Martha's Vineyard. They were married in 1998 and are living happily ever after.

At the age of sixty, Tom found his true love of reading, researching and writing the history of Martha's Vineyard. See thomasdresser.com for details.